Introduction for Electronic Media: Research and Application

Daniel J. Kurland
Frank Messere
Philip J. Palombo

 Wadsworth Publishing Company

I(T)P® An International Thomson Publishing Company

Belmont, CA • Albany, NY • Bonn • Boston • Cincinnati • Detroit
Johannesburg • London • Madrid • Melbourne • Mexico City • New York
Paris • San Francisco • Singapore • Tokyo • Toronto • Washington

For more information, contact Wadsworth Publishing Company,
10 Davis Drive, Belmont, CA 94002, or electronically at
http://www.thomson.com/wadsworth.html

International Thomson Publishing Europe Berkshire House 168-173 High Holborn London, WC1V 7AA, England	International Thomson Editores Campos Eliseos 385, Piso 7 Col. Polanco 11560 México D.F. México
Thomas Nelson Australia 102 Dodds Street South Melbourne 3205 Victoria, Australia	International Thomson Publishing Asia 221 Henderson Road #05-10 Henderson Building Singapore 0315
Nelson Canada 1120 Birchmount Road Scarborough, Ontario Canada M1K 5G4	International Thomson Publishing Japan Hirakawacho Kyowa Building, 3F 2-2-1 Hirakawacho Chiyoda-ku, Tokyo 102, Japan
International Thomson Publishing GmbH Königswinterer Strasse 418 53227 Bonn, Germany	International Thomson Publishing Southern Africa Building 18, Constantia Park 240 Old Pretoria Road Halfway House, 1685 South Africa

ISBN 0-534-52578-4

Contents

Section Two

Preface

This guide is designed to meet the needs of college students first encountering the Internet.

Section One is based on *The 'Net, the Web, and You: All You Really Need to Know About the Internet ... and a Little Bit More,* by Daniel Kurland. This section is divided into four chapters. Chapter One, "Introduction," suggests the range of Internet resources. Chapter Two, "The Basics," introduces key concepts essential to a discussion of the Internet. Chapter Three, "The Internet as Medium of Communication and Collaboration," discusses individual E-mail and various programs for broader communication dependent upon E-mail. Chapter Four, "The Internet Services," offers short descriptions of each Internet program and indicates how each is used.

Section Two offers more detail on the Internet and its specific use in electronic media research. Chapter Five, "The Internet and Searching Data," examines tactics and techniques for research in general and on the Internet in particular. Chapter Six, "The Internet as the Future of Wired Communication," offers a discussion of current technology and future trends. Finally, Chapter Seven provides an alphabetical listing of Web sites of use to the student and researcher.

Ultimately the best way to discover the Internet is on the Internet. This book is designed to get you started, and to be your companion as you explore. This is a work, then, both to be read at your leisure for a general understanding, and to be kept by your computer as a reference guide and handbook.

SECTION ONE

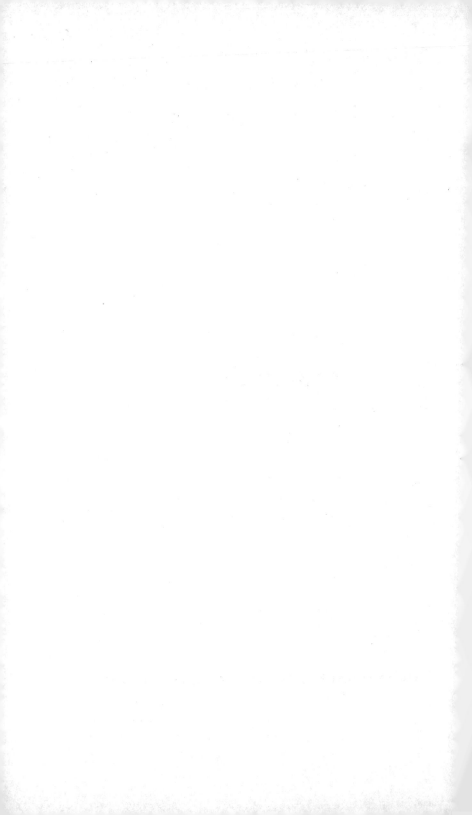

Introduction

<div style="text-align: right">**1**</div>

THE INTERNET

The Internet has been portrayed with a variety of images. Allusions are made to road systems ("the electronic superhighway"), Star Trek adventurers ("internauts in cyberspace"), and to a world community (the "electronic global village").

Initially, the Internet might best be seen within the historical development of human communication. At heart, the Internet is merely a new stage in humanity's ongoing attempt to meet people, exchange information, and explore the world of ideas. But it is also more than this.

The Internet is at once a mailbox, a research tool, a vehicle of commerce, and a medium of entertainment. You can send a letter to a colleague in Japan, check the score of the last Bullets game and the progress of a Senate bill, order a present for Aunt Harriet's birthday, listen to a sample track from a new CD, and find a recipe using avocados for supper tonight.

THE INTERNET AND THE COLLEGE STUDENT

Public discussion focuses on the Internet as a burgeoning electronic mall for cyber–consumerism and multimedia entertainment. For students and professors, the Internet has other purposes.

The Internet offers a broad array of academic and academic-related resources:

- professional and governmental archives and databases
- on-line journals
- access to commercial databases and abstract services
- professional discussion via newsgroups, mailing lists, and discussion groups
- academic and public library catalogs
- grant listings and deadlines
- directories of researchers and research projects funded by the federal government
- conference announcements and calls for papers
- academic, government and industry job announcements
- faculty biographies and university course descriptions
- educational and other software

In a broader vein, you can find the latest ferry schedule for Martha's Vineyard, browse advertisements for rafting trips, and download guides to doing your taxes.

Professors have used E-mail to post answer keys and grades, Gopher servers to archive lecture notes, and the World Wide Web to offer problem sets, interactive demonstrations, and supplementary course materials.

For graduate students and researchers, then, the Internet is an important resource for communicating with the community of scholars, for accessing sophisticated databases, for sharing information, and for investigating potential teaching/research programs.

For the undergraduate, the initial use of the Internet may be as a tool for communicating with the professor and other students. A secondary use may be to access information and discussion of real-world applications and policy issues. If you want to learn a particular discipline, study the textbook. If you want to review government documents, or discussion on issues within that discipline, surf the Internet.

The Basics

2

HOW TO GET ON

To obtain telephone service, you must subscribe to a telephone company. To access the Internet, you must connect to an Internet provider–a host or gateway providing an on-ramp to the Internet. When a host computer offers a specific service, it is referred to as a server in a client–server relationship.

Most colleges and universities provide some form of Internet access. At one extreme, access may be limited to specific computers in a computing center or laboratory. At the other extreme, wireless access may be available campuswide.

In general, Internet access will entail one of three options:

- direct linkage to the university network
- telephone access via modem to the university network
- telephone access via modem to a local or national commercial provider

If all else fails, Internet services are available from commercial on-line services such as American Online, Compuserve, and Prodigy. Contact your computing center to assess your options.

INTERNET ADDRESSES

Each account on the Internet is assigned a unique address. House addresses divide the world into physical regions: houses on streets, in towns, in cities. Internet addresses indicate computers on networks within networks.

Each level of the network is referred to as a domain. Thus the computer running the FTP program at the National Center for Supercomputing Applications (NCSA) at the University of Illinois at Urbana–Champaign (UIUC) has the address *ftp.ncsa.uiuc.edu*. This is the Internet way of indicating a particular computer *(ftp)* at a particular center (ncsa) within a larger university network *(uiuc)*. The final abbreviation indicates the nature of the account, here an educational institution *(edu)*.

The most common final domain extensions include

edu educational institutions

gov government institutions

com businesses or Internet service providers

mil military sites

net administrative organizations of the Internet

org private organizations

Foreign addresses include an additional two–letter country abbreviation at the end, e.g., *ftp.nsysu.edu.tw*, the address of the FTP program at the National Sun Yat Sen University in Taiwan.

All domain addresses have a numerical Internet Protocol (IP) address equivalent. IP addresses consist of four numbers separated by dots. The notation *141.142.20.50* is the same address as *ftp.ncsa.uiuc.edu.*

MAILING ADDRESSES

Domain addresses are equivalent to street addresses. But street addresses alone are not sufficient to designate the location of a specific individual. Many individuals may live in the same house with the same street address. Similarly, a number of users may access the Internet from the same host, and hence from the same Internet address.

For this reason, the address of an individual user consists of a username and a domain address: *user@domain*, pronounced "user at domain." The username and domain address together make up a complete Internet E–mail address.

Uniform Resource Locators (URLs)

Other than for E-mail transactions, most Internet activity involves accessing files on remote computers. Each file or directory on the Internet (that is, on a host computer connected to the Internet) can be designated by a Uniform Resource Locator (URL).

URLs indicate

- the program for accessing a file,
- the address of the computer on which a file is located,
- the path to that file within the file directory of that computer, and,
- the name of the file or directory in question.

Thus URLs have the form *protocol://IP Address/file path/filename.* Consider an example:

http://www.clark.net/pub/listserv/listserv.html

The first part of the address–*http://*–specifies the means of access, here Hypertext Transfer Protocol, associated with the World Wide Web. The address immediate following the double slash–*www.clark.net*–indicates the address of the computer (server) to be accessed.

Terms following single slashes–*/pub/listserv*–indicate progressively lower subdirectories on the server. And finally a specific file name–*listserv.html*–is recognizable by the period within the name and the *.html* ending indicating HyperText Markup Language–and is, again, associated with the World Wide Web. (URLs are indicated with *italics* throughout this text.)

There are URLs for all Internet protocols (telnet, FTP, Gopher, WAIS, http) as well as for E-mail addresses, file locations, and newsgroups.

For more information on URLs, see "A Guide to URLs," *http://www.netspace.org/users/dwb/url-guide.html.*

Internet Services

As noted earlier, other than for sending and receiving mail, time spent on the Internet generally involves accessing files on other computers. Any data manipulation or real creativity is done off-line on your own machine. There is, however, a wealth of material to be accessed.

All of the materials traditionally stored in a library–photographs and phonograph records, manuscripts and government documents, newspapers and academic journals, financial reports, employment listings, oral history tapes, and recipe collections–can be stored in electronic form. "We live in a world...," Raymond Kurzweil noted in his keynote address at the Second U.S./Canada Conference on Technology for the Blind, "in which all of our knowledge, all of our creations, all of our insights, all of our ideas, our cultural expressions-pictures, movies, art, sound, music, books, and the secret of life itself–are all being digitized, captured, and understood in sequences of ones and zeroes." And anything stored can be accessed.

The Internet offers a number of approaches to accessing stored materials:

- File transfer protocol (FTP)
- Browsing Gopher menus or World Wide Web pages
- Retrieving documents from WAIS databases

And each of these services has its own search program.

In addition, the Internet incorporates a number of services involving communication, including:

- Electronic mail (E-mail)
- Mailing lists (discussion groups and newsletter subscriptions)
- Newsgroups
- Talk and chat groups

Each of these services is examined in detail in Chapter Three. For additional materials, see the The Virtual Internet Guide (*http://www.dreamscape.com/Frankvad/internet.html*).

THE WORLD WIDE WEB: THE SERVICE OF CHOICE

In the past year, the World Wide Web has become the service of choice–if for no other reason than that it combines complex text with vivid graphics, audio, and movies. More importantly, almost all of the other services can be accessed via the Web, or at least by utilizing a Web browser. With this in mind, relevant Web sites are indicated throughout this text.

For those without Web access, all of the services discussed–including World Wide Web pages themselves–can be accessed via

E-mail. (See the reference to *Accessing the Internet by E-mail* in the section on electronic mail, page 11).

FILE FORMATS

Files on the Internet are often encoded, archived, and/or compressed.

Encoded Files

One of the most common means of file transfer is via E-mail. But E-mail files must be in plain ASCII format; neither the binary files generated by word processors nor graphic images can be sent via standard E-mail. (This is not an issue with MIME enabled E-mail or file transfer protocol.) How then can these files be transmitted?

Binary text files can be reformatted as plain ASCII text, but the display attributes (fonts, boldface, and so on) would be lost. The solution to the transmission problem involves encoding the files utilizing ASCII characters. The information necessary for the fonts and display attributes is recaptured by decoding the file back into binary format.

Files can be encoded and decoded using various protocols. Each such protocol is indicated by a file extension. Uuencode, a common format on the Internet, results in *.uue* files.

Archived Files

A number of files can be joined, packed, or archived into a single file for ease of file manipulation. The most common programs for combining files are the UNIX program tar (*.tar*), MS-DOS/Windows PKZIP/PKUNZIP, and Macintosh ZipIt (*.ZIP*) programs. Archived files must be unpacked before use. Archiving enables a number of files, or all files in a directory, to be manipulated with a single command.

Compressed Files

Files can also be compressed to shorten transmission time or to simply save storage space. Compression ratio varies with the type of file. Program files generally compress to about half their size (2:1), data files more than 5:1. The UNIX compress/uncompress program (*.Z*) is often used in conjunction with the archiver tar, resulting in files of

the form *.tar.Z. Some programs, such as PKZIP and ZipIt, combine archiving and compression capability.

For instructions, refer to "How to Decode and View Binary Messages" on the Usenet newsgroups *alt.binaries.pictures.d* and *new.newusers.questions* and the Frequently Asked Questions file for the newsgroup *comp.compression (http://www.cis.ohio-state.edu/ hypertext/faq/usenet/compression-faq/top.html)*.

GETTING HELP

Computer education has always been a social affair. When in need of help, users ask friends or colleagues who are, generally, only one step ahead in their computer expertise.

For most students, help is as close as their computing center. Many computing centers provide handouts and offer minicourses. Guides to the use of services and software are often posted on university networks.

On-line Guides

An extensive menu of guides to all aspects of the Internet and its resources is maintained by John December (*http://www.december.com/net/tools/index.html*).

Frequently Asked Questions (FAQs)

Responses to frequently asked questions are available as FAQ files. There are FAQs for almost all aspects of Internet content and use:

alt.fan.monty-python FAQ

Anonymous FTP Frequently Asked Questions (FAQ) List

Economists' Resources on the Internet

FAQ: How to find people's E-mail addresses

How to Read Chinese Text on Usenet: FAQ for alt.chinese.text

Copies of FAQs are generally available from the relevant Usenet newsgroup, or are posted on the newsgroups *news.announce.newusers, news.answers,* or *news.newusers.questions.*

FAQs are also archived in various locations. Copies of all FAQs can be browsed at *http://www.cis.ohio-state.edu/hypertext/faq/ usenet/FAQ-List.html* or *http://www.intac.com/FAQ.html.* For in-

structions on obtaining FAQs by E-mail, and a complete list of
Usenet FAQs, send an E-mail letter to

mail-server@rtfm.mit.edu

Leave the subject blank and include the message

send usenet/news.answers/Index

followed by the line

help

with no period or subject heading.

FAQs are always a useful starting point for investigating any
Internet topic.

RFCs and FYIs

The Internet Engineering Task Force (IETF) provides a series of
documents called Requests for Comments (RFCs) on a broad range
of Internet topics. While many are highly technical, others offer
introductions to major topics. FYIs (For Your Information), a subset
of the RFCs, are particularly useful for new users (newbies). FYIs
include FAQs and "How To" guides for the various services. FYI: 23,
Guide to Network Resource Tools (*http://www.ftp.com/techsup/
fyi/fyi23.html*) describes all of the Internet services.

An RFC search page is available on the World Wide Web at
http://ds.internic.net/ds/dspg1intdoc.html.

The Internet as Medium of Communication and Collaboration

3

ELECTRONIC MAIL (E-MAIL): THE INTERNET AS POST OFFICE

Academic research relies on the efforts of a community of scholars. Central to this effort is communication. The major use of the Internet—by scientists as well as by others—is electronic mail and a number of other communications services based on electronic mail.

E-Mail

In many ways, E-mail is truly revolutionary. E-mail travels anywhere in the world in minutes, not days. You can send a document thousands of miles for the price of the phone call to your Internet provider. When you are having trouble getting through to someone on the phone: E-mail. Can't get past a secretary? E-mail.

In other respects, little has changed. You still have to have something to say to someone, and you still have to know that person's address. There is still the excitement of discovering that you have mail—and still the nuisance of wading through junk mail.

The Internet delivery system can overcome many problems, but it is not foolproof. Lines may be down or computer systems may be out. Excessive traffic may slow access to a particular location—and even the Internet cannot surmount an incorrect address. E-mail

reports back unknown addresses and problems with delivery, but regular mail is more forgiving of simple errors in addresses.

All of the services of the Internet can be accessed via E-mail–albeit often in a very limited manner. For complete instructions, see "Accessing the Internet by E-mail, Doctor Bob's Guide to Offline Internet Access." The document can be obtained by sending an E-mail letter to *mail-server@rtfm.mit.edu* with the message

**send usenet/news.answers/internet-services/
access-via-email**

with no final punctuation.

Using E-Mail

E-mail programs are part word processor, part mailbox, and part file organizer. With almost all you may

- list mail received and mail sent
- read or delete an item from the list of documents received
- print or save a document as a file
- store frequently used names and addresses
- automatically attach signatures at the end of letters
- send replies, with portions of the original message in the reply
- forward mail by simply readdressing it
- attach other files to mail
- send a document to any number of people at once

The final feature facilitates the postal equivalent of the traditional telephone tree and enables a number of additional services considered below.

While the standard text-interface programs (mail, pine, and elm) are not particularly user-friendly, here, as elsewhere, the command **?** or **help** will usually evoke a list of commands, regardless of the program you are using. A graphic-interface program such as Eudora (Figure 1) greatly simplifies the process.

Social Considerations

Ever resourceful, E-mail users both speed their task and qualify their remarks with acronyms such as BTW (by the way), IMHO (in my

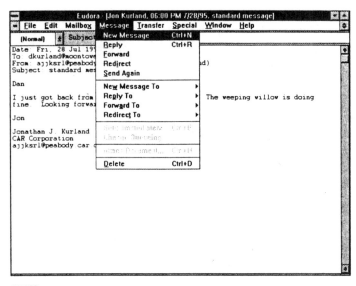

FIGURE 1 Message options on the Eudora mail program for Windows.

humble/honest opinion), FWIW (for what it's worth), and OTOH (on the other hand). Words are stressed by enclosing them in *asterisks*.

Ever playful, E-mail users have also developed a series of symbols (emoticons) to replace voice inflection and facial expressions in their letters. The most well known of these symbols is the smiley, a keyboard-written image indicating delight with an idea: :-)

Finally, users of the Internet constitute their own subculture, one that has definite standards of fair play and respect for others (netiquette). One should not YELL BY WRITING EVERYTHING IN CAPITAL LETTERS nor forward mail to large groups of people (spamming).

Sending E-mail in the privacy of your room, you might think your remarks are truly private. This is hardly the case. E-mail can be read by system administrators or your Internet provider. Mail you send to one person may be forwarded intact–or edited–to others without your knowledge or permission.

Since E-mail messages tend to be shorter than most other correspondence, you must take care not to be vague, ambiguous, or suggestive. Use sarcasm and humor cautiously to avoid misunderstandings.

Finding Addresses

Since there is no definitive Internet, there is no definitive directory of Internet names and addresses. The best way to learn a person's E-mail

address is still to call the person on the telephone, or ask someone else. If that fails, you can try a number of search programs examining portions of the system. Try Four11(*http://www.four11.com*) or Yahoo's list of sites (*http://www.yahoo.com/reference/white_pages/individuals/*).

THE INTERNET AS BULLETIN BOARD, BULL SESSION, AND PARTY LINE

Mailing Lists

The same process by which a single E-mail message can be directed to another person can be used to distribute documents–almost as with traditional mailing lists.

Individuals subscribe by E-mail and receive material periodically via E-mail. (Nonsubscribers can usually request individual items from the mailing list via E-mail.) Since all such mailing list activities involve E-mail, the only software required is an E-mail program.

In many instances, subscription mailing lists are administered by a computer. The first such program was LISTSERV, giving rise to the name *listservers*. Similar programs go by the names *majordomo*, *MAILSERV*, and *listproc*.

Server computers automatically read and respond to requests to start, stop, or pause subscriptions. Most such programs oversee more than one list at a single site. A sure sign that a mailing list is administered by machine is that the contact address refers to one of the above programs. Listservers commonly archive correspondence in log files that can be retrieved by E–mail.

Administrative tasks are usually accomplished by single-word commands–commands that vary with the listserver program involved. An E-mail letter to a listserver with the single word **help** in the body of the letter will usually evoke a reply with a list of appropriate commands.

Mailing lists are used by professional groups, on-line newsletters and magazines, and other information and advocacy services.

Discussion Groups

With mailing lists, a single person or central authority produces documents for distribution to subscribers on a fairly regular basis. Discussion groups are more like a giant bull session. Anyone can contribute a message, which is then forwarded to all subscribers.

Any group of people with a common interest can form a discussion group. Groups have been formed to discuss new software programs, research interests, or simply hobbies or political issues. Many listserver discussion groups are associated with academic organizations, associations, and societies.

Some discussion groups forward all correspondence; some are moderated by an individual to assure the relevancy of the discussion; some incorporate messages into a periodic newsletter. Some groups are open; some have membership restrictions (via password).

Listerver discussion groups are also referred to as electronic mailing groups, or, just to confuse matters, mailing lists. Alternatively, they are labeled by reference to the computer managing the group: listservers.

Two warnings are in order. First, you must carefully distinguish between the address of the server that administers the distribution of messages (usually in the form *listserv@address*) and the address of the discussion group to which you send contributions (usually in the form *groupname@address*).

Secondly, provocative news items can trigger a deluge of comments from an ever-increasing membership. Since each subscriber receives all correspondence, hundreds of letters may suddenly appear in your mailbox!

Finding Mailing Lists and Discussion Groups The document "Publicly Accessible Mailing Lists" is posted regularly on the Usenet newsgroup *news.answers*. It is also available by anonymous file transfer protocol (*ftp://rtfm.mit.edu/pub/usenet-by-group/news.answers/mail/mailing-lists*). A listing of listserv groups can be obtained by E-mail from *listserv@ubvm.cc.buffalo.edu* with the message:

list global */modifier*

where *modifier* indicates a specific search term within newsgroup titles or descriptions.

A number of World Wide Web programs allow you to search publicly accessible mailing lists (and often newsgroups, as well). Some provide hotlinks for obtaining subscriptions or further information (Figure 2).

Liszt: Searchable Directory of E-mail Discussion Groups

http://www.liszt.com/

Mailing Lists WWW Gateway

htlp://www.netspace.org/cgi-bin/lwgate

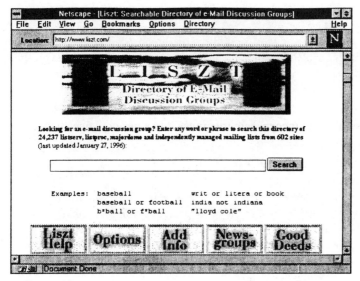

FIGURE 2 Liszt, a World Wide Web search program for access-
ing discussion groups that utilize the major listserver
programs.

You should, of course, run a number of searches with slightly differ-
ent search terms to assure that you catch all relevant sites.

Newsgroups

Mailing list and discussion group messages are E-mailed to individ-
ual subscribers. With newsgroups, E-mail messages are posted on
a variety of independent networks for anyone to read and respond.
Primary among these networks is Usenet (User's Network), a large
portion of which is carried by the Internet.

Usenet newsgroups provide a forum through which people can
gossip, debate, and discuss shared interests, a conferencing system
by which people from all walks of life can inform, argue with, query,
and harangue each other. Newsgroups are often used to distribute
the latest versions of FAQs relating to popular software or any other
interest area.

Seven categories of newsgroup postings are distributed world-
wide: *news, soc, talk, misc, sci, comp,* and *rec.* There is also an *alt*
category, a miscellaneous heading for anything that does not fit
elsewhere, and *biz* for business-related groups. In addition, there
are subcategories that are limited to a specific institution or geo-
graphic area, as well as specialized newsgroup feeds such as the

news service ClariNet, the BioNet network, and the history mailing list H–Net.

Some such networks combine mailing lists and newsgroups. All messages are both sent to subscribers via E–mail and posted on the appropriate newsgroup.

New users should consult the FAQ posted in *news.announce.newusers* or visit the World Wide Web Usenet Info Center site (*http://sunsite.unc.edu/usenet-i/*).

Using Newsgroups Each newsgroup contains collections of postings or articles that are essentially E-mail messages. Postings on the same topic are assembled into threads.

A special newsreader program is required to read and respond to the postings. Such a reader (the program, that is) typically allows users to subscribe to a specific set of groups from a list of three to four thousand available on any single network. Other newsgroups can still be retrieved, but the system does not have to load all of the messages when starting.

Newsreaders indicate the number of new articles available in each subscribed group. You can save or print a file, search for a particular term, mark files as read, go to the next article in a thread of responses, or respond directly to the author of an article with a new posting (Figure 3).

All newsgroup files are in text mode; graphics and sound files must be decoded prior to viewing.

Finding Newsgroups The search program eXcite (*http://www.excite.com*) can be used to search Usenet groups by keyword or concept. Dejanews (*http://www.dejanews.com/forms/ dnquery.html*) searches the text of Usenet archives. The Usenet Info Center, cited above, also offers browsing and searching capabilities for Usenet groups.

Social Considerations Usenet groups are at once the essence and the bane of the Internet. Of all sites on the Internet, newsgroups are the preferred venue for uninhibited surfing and lurking (technical terms for scanning and reading without responding). The level of discussion can vary from the intellectual to the puerile, from mainstream to radical. While some newsgroups are moderated for content, discussion is generally uncensored, encouraging a range of belief and expression with which many are uncomfortable. As the forum for the freest expression on the Internet, newsgroups are often subject to restrictions or outright censorship.

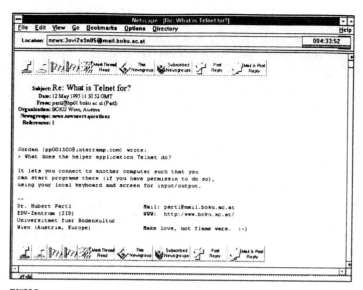

FIGURE 3 A newsgroup posting viewed with the newsreader built
into the World Wide Web browser Netscape. Note the
command options at the top and bottom of the screen.

Since the anonymity of Internet communication can give rise
to relatively antisocial behavior, guides to Internet etiquette ("neti-
quette") outline traditions of acceptable behavior, such as posting
a message to only one newsgroup at a time. Chuq Von Rospach's "A
Primer on How to Work with the Usenet Community," a guide to using
Usenet politely and efficiently, is available at *news.newusers.questions.*
Arlene Rinaldi's "The Net: User Guidelines and Netiquette" is avail-
able at *http://rs6000.adm.fau.edu/rinaldi/net/index.htm.*

Talk and Chat Programs

Two other Internet communication programs do not rely on E-mail,
but are somewhat simliar in their effect. Talk programs allow two
people to "talk" by typing remarks back and forth without exiting
their screens. They offer text-based on-line communication.

Chat programs are simply group talk programs. They work some-
what like citizens band radio. Participants can often choose from a list
of available chat groups. They can enter or exit a discussion at will,
identified only by a handle or nickname they have selected.

Using Talk and Chat Programs Internet talk programs can be initiated at the provider prompt with a **talk** command and an E-mail address. The recipient, assuming he or she is on-line at the time, receives an on-screen message indicating that a session has been initiated. The recipient has only to respond with the same command and the appropriate return E-mail address. A newer program, ntalk ("new talk," of course), is also available.

The Internet version of a chat program, Internet Relay Chat (IRC), requires special software. (For further information, see the newsgroup: *alt.irc*)

New chat programs reflect the general evolution of the Internet toward increasingly sophisticated audio and graphics programs–and with that, a requirement for faster and faster computers, modems, and sound boards. Worlds Chat (*http://www.worlds.net/*) provides a virtual three-dimensional room with photographs of the participants, and Global Chat (*http://www.qdeck.com/chat/globalstage/ servers.html*) adds both sound and graphics to an otherwise text-based chat session.

Add real-time voice and chat programs mimic telephones. Internet Phone (*http://www.vocaltec.com*) enables real-time voice conversations between two people. CUSeeMe (*http://magneto.csc.ncsu.edu/ Multimedia/classes/Spring94/projects/cu-seeme.html*) allows real-time voice and video conferencing utilizing the Internet.

The Internet Services

4

TELNET: THE INTERNET AS REMOTE CONTROL

Here we begin a survey of the programs available on the Internet. We start with the most general, the plain vanilla operation of simply gaining access to another computer. The program for doing this is called telnet.

Telnet

You can extend the cables of your computer via telephone lines to access the files of a remote computer. The keyboard and screen are your own, but you are "using" another computer.

Remote control of another computer is hardly new with the Internet. You run another computer when you dial up a bulletin board or participate on an office network. What is different with the Internet is the number of activities, and the physical range, available to you.

Many library catalogs, community bulletin boards, and academic and governmental information sites are accessible via telnet. Most of the activities of the Internet can be accomplished by telneting to public access sites.

Using Telnet

As with many Internet terms, the word "telnet" has a number of forms. You use the **telnet** command of the telnet program to telnet to a remote computer.

Upon gaining access to the Internet, simply type the command **telnet** and an address:

>prompt% **telnet archie.rutgers.edu**

(Here, as throughout this book, commands and user input are **boldfaced**.) The telnet program contacts the computer at that address using the numerical IP address, waits for a response, and reports its status.

>Connected to dorm.Rutgers.EDU.

What happens then depends on where you've telneted to, and the degree to which that site allows public access. As with most other programs, you can obtain a list of possible commands by issuing the command **help** or **?** at the new prompt.

For more information on Telnet, see "Telnet Tips" at *http://galaxy.einet.net/hytelnet/TELNET.html.*

Hytelnet, a database of telnet–accessible sites with appropriate login commands is available by file transfer protocol (*ftp://access.usask.ca/pub/hytelnet*). Alternatively, you can access telnet sites through a search program on the World Wide Web at *http://galaxy.einet.net/hytelnet/HYTELNET.html* (Figure 4).

FILE TRANSFER PROTOCOL AND ARCHIE: THE INTERNET AS LENDING LIBRARY

File Transfer Protocol (FTP)

FTP is a procedure for downloading files from remote computers.

You cannot access any computer, nor can you access everything on a specific computer. The computer in question must be connected to the network and must grant public access to specific directories and activities.

Computers that archive files and grant public access to selected directories are said to offer anonymous file transfer. Roughly three thousand sites provide anonymous FTP service. Two-thirds of these sites are in the United States, and three-fifths of those are located at educational institutions.

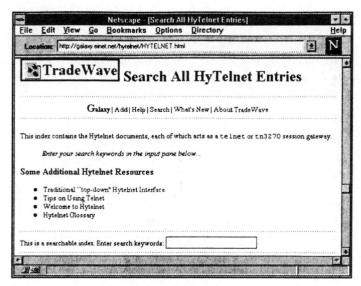

FIGURE 4 A World Wide Web search program for Hytelnet, a catalog of informational sites publically accessible by telnet.

Anonymous FTP archives are an excellent source of Internet software as well as specialized educational and research programs. Documents, position papers, newsletters, photographs, sound files, animated movies, and movie clips are all available by FTP.

Using FTP

FTP servers can be accessed via telnet, from a local FTP host, with graphic-interface programs, or by indicating the URL for an FTP address with a World Wide Web browser. Finally, most documents obtainable via anonymous FTP can be obtained via E-mail.

FTP file retrieval is pursued much as it would be on your own computer. Whatever software program you employ, the sequence is the same:

1. Access the remote computer.
2. Login with a username ("anonymous") and password (by tradition, your E-mail address).
3. Move from subdirectory to subdirectory with change directory (cd) commands to locate the desired file.
4. Read or download the desired file.

5. Repeat steps 3 and 4 as desired.

6. Logoff.

To access an anonymous FTP site with a text-interface program, enter the **ftp** command followed by the address of the desired site at the Internet provider's prompt:

prompt% **ftp address-of-FTP-archive**

You can access a list of subsequent commands by issuing the command **help** or **?** at the FTP prompt.

With a graphic–interface program or World Wide Web browser, you maneuver through directories by clicking on subdirectory names or icons. You request files by clicking on the filename or icon. Graphic-interface FTP programs usually allow you to maintain a directory of FTP addresses. Simply select an address and the program logs you in and accesses an initial directory (Figure 5).

A complete list of FTP sites generally serves little purpose. We have, after all, little use for a list of all of the libraries in the country; we are more concerned with knowing what books exist and where to find them. Similarly, on the Internet we are more concerned with identifying specific files and their location than with a list of the locations where files might be stored. Neveretheless, a list of Internet sites accepting anonymous FTP is maintained by Perry Rovers at *http://www.info.net/Public/ftp-list.html.*

Instruction in the use of FTP is available in the form of a FAQ document via E-mail from *mail-server@rtfm.mit.edu.* Include no subject and only the message:

send usenet/news.answers/ftp-list/faq

with no final punctuation. You can access FYI 24, How to Use Anonymous FTP (*http://www.ftp.com/techsup/fyi/fyi24.html*).

Finally, file transfer from remote computers is not a right. It is a privilege that carries with it distinct responsibilities, such as not downloading files during peak hours. For additional guidance, see the FTP guides above or "The Net: User Guidelines and Netiquette" referred to in the section on newsgroups (page 17).

Archie: The Card Catalog

File transfer protocol provides access to files on computers around the world. But how do you know where to look for a particular file, or for any file of a particular type? You can burrow through the sub-

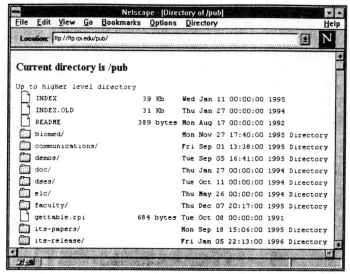

FIGURE 5 A directory listing from an FTP session using the Netscape World Wide Web browser. The options on this screen include returning to the previous level of the directory, displaying text files (indicated by page icons), or proceeding to lower level directories (indicated by file folder icons). The INDEX and README files are generally a useful starting point for any search.

directories and read the indexes on one computer after another, but this is obviously both time consuming and inefficient.

As with other aspects of the Internet, much of your information will come from word of mouth. A magazine article will mention a file. A *read.me* file will refer to another document or program. A newsgroup posting will announce a new program or document. In each case, the address of a relevant FTP server will usually be supplied.

As useful as these resources may be, they will not always suffice. Some means of searching available files is still necessary.

Since the Internet has no center, no central card catalog is possible. A reasonable facsimile, however, is recreated every month at a number of locations by a service and search program called Archie. Sites that offer anonymous FTP register with an Archie service. Over a period of a month, the Archie service scans those sites and generates a list of files and directory names. The resulting database is then mirrored on several other Archie servers, all of which then contain the same information.

Using Archie

Public-access Archie servers are reached by the **telnet** command and a suitable address. Obtain a list of such sites from *telnet://archie.ans.net.* Login as "archie" (all lowercase) and type "servers" at the first prompt.

Alternatively, if Archie is installed on your host system, accesss Archie by issuing the **archie** command with no address specified.

Upon reaching an archie server, sign on with the username "archie". No password is necessary. To search for a specific program, type the command **prog** followed by the name of the program. The command **help** or **?** at the archie prompt will list other available commands.

Archie servers often indicate your place in line (queue position) and the expected time of completion of a search. While there are thousands of FTP servers, there are a limited number of Archie servers. A queue position of 35 is not uncommon. If the anticipated delay is long, simply try another server. In most cases, a server will offer a list of other active servers.

As with graphic-interface FTP programs, graphic-interface Archie programs store lists of server addresses and automatically submit the userid "archie" at the login prompt.

Archie searches combined with FTP retrieval are available at various Web sites, including the Archie Request Form at NCSA (*http://hoohoo.ncsa.uiuc.edu/archie.html*) (Figure 6).

GOPHER AND VERONICA: THE INTERNET AS RESEARCH LIBRARY

Gopher

Gopher is a tool for burrowing or tunneling through file resources on the Internet. It is akin to browsing from a document in one library to another document in another library.

Gopher is based on menus. Gopher menus point to other menus, which ultimately point to specific documents, whether text, picture, animation, sound file, or search program on the same or other computers.

While all types of files can be accessed using Gopher, a Gopher screen displays either a menu or a document–no graphics, fancy fonts, or icons. Sound and graphics files must be downloaded for viewing later.

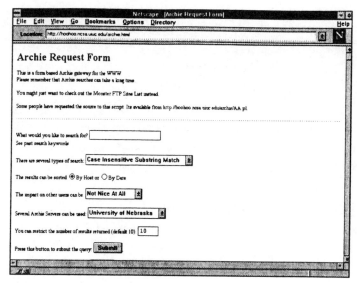

FIGURE 6 A World Wide Web Archie program. Note the search options.

As with other services, you can access only what someone lets you. Gopher sites are for the most part located at academic institutions and government agencies. The resulting materials are therefore of an academic/research/statistical nature. Entertainment, commercial, and lifestyle resources tend to be cataloged on the more recent World Wide Web.

Using Gopher

You can access Gopher menus in various ways.

If your Internet provider offers no Gopher service, you can use the **telnet** command to access any of a dozen or so public-access Gopher sites.

If Gopher service is offered by your Internet provider, the **gopher** command alone accesses the provider's initial menu and the **gopher** command followed by an address reaches a specific Gopher site anywhere in the world.

Finally, you can access specific Gopher sites with specialized graphic-interface programs or a World Wide Web browser.

Since all Gophers provide access to all Gopherspace, you can get to any Gopher from any other.

One of the standard starting points on most systems is a topic-oriented menu called Gopher Jewels. With text–interface, the initial menu looks like this:

Gopher Jewels

1. GOPHER JEWELS Information and Help/
2. Community, Global and Environmental/
3. Education, Social Sciences, Arts & Humanities/
4. Economics, Business and Store Fronts/
5. Engineering and Industrial Applications/
6. Government/
7. Health, Medical, and Disability/
8. Internet and Computer Related Resources/
9. Law/
10. Library, Reference, and News/
11. Miscellaneous Items/
12. Natural Sciences including Mathematics/
13. Personal Development and Recreation/
14. Research, Technology Transfer and Grants Opportunities/
15. Search Gopher Jewels Menus by Key Word(s) <?>

Page: 1/1

Markings at the end of each line indicate the nature of each menu item. A right slash, / , indicates that the item leads to a lower-level menu. The question mark within brackets, < ? > , indicates a searchable database.

Since Gopher is menu-based, text–interface and graphic-interface sessions look pretty much the same (Figure 7).

Negotiating from one Gopher menu to another is accomplished with cursor keys or by clicking on icons. To select a menu item, simply move the cursor to the item and hit the enter key or point and click with a mouse. The Gopher program issues a telnet, FTP, or other command to access that item.

If you reach a dead end, double back to an earlier choice by clicking on an icon representing the earlier menu or, with a text-based system, by hitting the left cursor.

Gopher programs allow you to create a personal menu of your favorite Gopher sites (bookmarks) for later use. The Gopher FAQ is located at *gopher://mudhoney.micro.umn.edu/70/00/gopher.faq.*

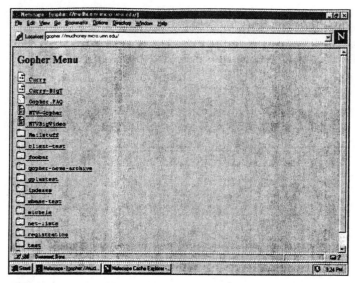

FIGURE 7 Gopher menu viewed with a World Wide Web browser.

In the end, Gopher is essentially a browsing tool. You can pursue material on specific topics, but since you have to hunt around, it is not really a search program. Gopher is also a retrieval program. (You will recall that file transfer protocol was a retrieval program, not really a search tool, and Archie a search tool but not a tool for retrieval.)

The value of Gopher is in great part not only what you find at the end of your travels but what you discover along the way. The investigation itself will often suggest additional topics and resources you may never have imagined.

Veronica: Searching with Gopher

As a browser, Gopher offers a slow and haphazard approach to research. A more direct route is available, however.

Veronica (Very Easy Rodent-Oriented Net-Wide Index to Computerized Archives) builds a searchable index of Gopher menus in much the same way that Archie builds an index of FTP files. Every week, about a dozen Veronica sites search and index the titles in menus of registered Gopher servers. The result is a searchable database of virtually all of the Gopher servers in the world.

Veronica goes one step further. Archie told you where files were; you had to get them yourself using FTP. The output from a Veronica

search is a custom Gopher menu. Veronica is thus both a search and a retrieval tool.

Since Veronica is a tool of Gophers, it appears as an option on the initial menu of most Gopher servers. There is no need for a **veronica** command. If one of the Veronica indexes is unavailable due to high traffic, simply try another (Figure 8). The home base for Veronica is at *gopher://veronica.scs.unr.edu/11/veronica.*

Jughead (Jonzy's Universal Gopher Hierarchy Excavation and Display), a variant of Veronica, searches file names and directories on a select number of Gophers or the immediate Gopher server.

Using Veronica

Veronica searches menus, not the contents of the Gopher servers themselves. Veronica indexes do, however, include additional items, such as titles from World Wide Web servers, Usenet archives, and telnet information services that are referenced on Gopher menus.

Veronica searches are not case-sensitive (searching for Tuba will locate TUBA, tuba, and Tuba), and Veronica understands the Boolean logical operators AND, NOT, OR (a blank is assumed to be AND). Additional commands allow you to restrict the search to certain types of files or a maximum number of responses. Veronica also supports partial word searches in which an asterisk "*" represents a wild card character or characters. "Go*" will return all items that have a word beginning with "go" in the title.

Veronica search terms will appear in every menu item. This is as it should be; after all, searches are defined as searches for specific words in menu titles. But such a search will obviously fail to include closely associated items or similar items described in different terms.

Here, as in all research, there is a distinct art to selecting the proper search terms. Try alternate searches using synonyms or more general terms to assure yourself that you are capturing all of the relevant references. If a search yields an inordinate number of responses, search again with a more limited search term. If you desire more options, search again with an alternative phrase or more general terms, or browse some of the sites indicated and see what you find.

When you know exactly what term or phrase best describes what you are looking for, a Veronica search can be more direct–and potentially more fruitful–than simply following Gopher menus.

For an extended discussion of Veronica search techniques, see the FAQ document "how-to-query-veronica" offered with Veronica menus.

FIGURE 8 A World Wide Web Veronica interface.

WAIS: SEARCHING DOCUMENTS

WAIS

Archie searches file names in directories of anonymous FTP servers; Veronica searches key words in Gopher menus. Neither examines documents themselves, only their listing in a directory or menu. WAIS (pronounced "waze"), on the other hand, is specifically document oriented.

The WAIS (Wide Area Information Servers) information retrieval system on the Internet is an application of a more general search protocol. WAIS examines the full text of all of the documents on a particular database. It searches for key words and ranks documents according to the number and placement of the "hits." Like Veronica, WAIS offers a menu from which you can then retrieve documents.

In actual fact, WAIS searches not documents but *indexes* of the text of documents. As a result, the WAIS database can include anything that can be indexed with words. Descriptions of insects or works of art can be indexed to pictures of the items. Descriptions of songs can be indexed to sound files. In the end, however, you can only access what has been indexed.

There are roughly six hundred free public databases, each devoted to a particular collection of materials, each with the *.src* extension indicating a WAIS database.

WAIS databases exist for newsgroups, professional journals, and bibliographies. They include databases of Hubble Space Telescope Instrument Status Reports, U.S. Department of Agriculture commodity market reports, and the Columbia Law School card catalogue. Fewer WAIS databases exist for nonacademic areas or for topics for which the relevant materials are widely dispersed.

Using WAIS

WAIS can be accessed by the telnet command at *quake.think.com* (login as "wais") or at a number of other public-access sites, as an option on some Gopher menus, or via the World Wide Web (*http://www.ai.mit.edu/the-net/wais.html*) (Figure 9). It can also be accessed by E-mail at *WAISmail@quake.think.com.* (Here again, the message "help" will elicit a list of the proper commands.)

A WAIS search involves a number of steps:

1. Select the appropriate database(s) (sources)
2. Select key-word search term(s) (questions)
3. Indicate the maximum number of responses desired
4. Search the specific database(s)
5. Review the results and access specific files

If you do not know which database to search, you can first search a directory of servers, *directory-of-servers.scr*, and then select appropriate databases from the initial output (Figure 10).

A listing of public-access WAIS databases is available in compressed form at *ftp://quake.think.com/pub/directory-of-servers/wais-sources.tar.* The WAIS FAQ is available from *ftp://quake.think.com/pub/wais-doc/waisfaq.txt.*

As with Veronica searches, WAIS searches must be executed with care. A single word can have different meanings in different contexts. You must, then, decide how relevant the resulting hits actually are, and re-search if necessary.

A search on the word "table," for instance, would locate references to furniture (kitchen table), economic charts (statistical tables), and parliamentary procedure (table a motion). To be more specific in your search, you might search on additional terms that are likely to occur in the same context. Alternatively, newer WAIS programs allow for relevance checking, a means of refining a second search based on the results of the first. Newer programs also allow the use of Boolean logic in search terms.

FIGURE 9 A World Wide Web site offering access to WAIS searches.

FIGURE 10 Initial WAIS search results searching on the question "health" in the *directory–of–servers.src* database, listed by score.

Above all, you must be careful not to assume that a lack of citations necessarily implies a lack of evidence. It may be that you just didn't look as imaginatively as you might have.

WAIS is most suitable when you are looking for unspecified information related to a very specific term or are searching a select database for known information. If you want to find out about the American welfare system, Gopher or the World Wide Web would be a more appropriate resource.

THE WORLD WIDE WEB: THE INTERNET AS MULTIMEDIA

Of all the aspects of the Internet, the World Wide Web (WWW) has evoked the greatest hyperbole. Laurie Flynn, in *The New York Times,* referred to it as "an electronic amalgam of the public library, the suburban shopping mall and the Congressional Record," while Peter H. Lewis, in the same newspaper, referred to it as "a time-sucking black hole...a speedtrap on the data highway, a Bermuda Triangle in the information ocean, the junk food aisle in cyberspace's digital supermarket."

The Web, as it is often called, is the fastest growing service on the Internet. In just a few years, it has become an integral, and for some indispensable, part of the culture.

As with Gopher, the World Wide Web is a means of accessing files on computers connected via the Internet. The World Wide Web is not a physical place, nor a set of files, nor even a network of computers. The heart of the World Wide Web lies in the protocols that define its use. Yet it is the appearance of the Web that is most striking.

The Look!

Each Web site opens with a home page, "a combination frontispiece, greeting room, table of contents, hub, and launching pad," in the words of Michael Neubarth, editor-in-chief of *Internet World.*

Gopher menus can lead to files that contain pictures or sound or even movie clips, but the overall presentation of the menus is text. A typical Gopher menu, even viewed with a graphics program, still looks like a menu of items (Figure 7). The World Wide Web, on the other hand, is the only truly multimedia presentation on the Internet. You have only to look at a World Wide Web screen to see the difference (Figure 11)!

FIGURE 11 Thomas World Wide Web home page utilizing graphics.

FIGURE 12 Thomas World Wide Web page viewed with the text-interface browser Lynx. Note the indication of the number of screens for the complete page at the top.

A Web page has all of the aspects of sophisticated desktop publishing: diverse typefaces, charts and forms, icons and integrated graphics. Sound and movies can even be integrated into the presentation. Recent increases in computer speed have spawned applications utilizing real-time sound and 3-D or virtual reality graphics.

To be sure, the World Wide Web can be accessed with a text interface, but it has none of the panache of the graphics version. Elements that appear highlighted by color in a graphic interface appear as underlined or shadowed text (Figure 12).

What's Behind It All: Hypertext

The World Wide Web is based on the notion of links within hypertext pages.

In hypertext, key concepts and ideas are linked to the address of related material, in much the same manner that each item in a Gopher menu is encoded with the location of the requisite menu or file. Links within the discussion are indicated by highlighted terms, icons, or simply locations on the page called hotspots. Click on a hotspot, and you access the linked item, be it another Web page or any one of a number of the other Internet services. Footnote numbers can provide direct access to the original sources. Links can be inserted into maps and drawings. You can click on a room in a blueprint and see a photograph of that room.

The overall effect is not unlike reading an encyclopedia with the ability to snap your fingers to instantly shift to another page, another book, or even a phonograph or slide projector! You do not need to follow a predetermined sequence of ideas. You can branch off as your interests dictate.

Hypertext Transfer Protocol (HTTP)

Hypertext linkage is accomplished with Hypertext Transfer Protocol (HTTP), the main operating system of the World Wide Web–hence the URL notation *http://*. This protocol contains the instructions to connect to a remote computer, request a specified document, receive the document, and sever the connection.

Hypertext Markup Language (HTML)

The coding of a World Wide Web page is done with Hypertext Markup Language (HTML). Just as a word processor inserts codes to indicate fonts and font sizes, paragraph breaks and boldface, so HTML inserts tags or elements to accomplish the same effects. The resulting format is seen only when the page is read by a Web browser.

The following is the HTML document underlying the Thomas home page. Addresses are indicated in universal resource locator

(URL) notation. On-screen text has been marked in boldface to distin-
guish it from the hypertext markup language coding. Hyperlinks,
indicated on screen by a contrasting color, are indicated here in italics.

<!doctype html public "-//W30//DTD WWW HTML 2.0//EN">
<HTML>
<HEAD>
<TITLE>**THOMAS: Legislative Information on the
Internet**</TITLE>
<!BASE HREF="http://thomas.loc.gov/home/thomas.html">
</HEAD>
<BODY>
<img src= "http://thomas.loc.gov/home/thom_mas.gif"
alt="[Thomas
Jefferson logo] ">
<P>**In the spirit of Thomas Jefferson,**
**a service of
the
U.S. Congress through its Library.**
<HR>
Jump to:

Full Text of Legislation |
Full Text of the<I>*Congressional
Record*</I> |
<I>*Congressional Record Index*</I> |
Bill Summary & Status |
Hot Legislation |
*The U.S.
Constitution* |

<I>*How Our Laws Are Made*</I> |
U.S. House of Representatives |
U.S. Senate |
*Congressional Commissions and Advi-
sory Boards* |
C-SPAN |
*THOMAS
Usage Statistics* |
Update Policy |
*Other Library of Congress Government
Resources* |</P> <HR>

<P>
**Full Text of
Legislation**

`
`**Full text of all versions of House and Senate bills searchable by keyword(s) or by bill number.**``
``
``***104th Congress Bills***``

...................................

Notice that an HTML document, unlike a document produced with a word processor, is in plain ASCII text. The result is a universally accessible page that can be read by browsers using any operating system, whether Windows, Macintosh, or UNIX.

For discussion of Hypertext Markup Language, see A Beginner's Guide to HTML (*http://www.msg.net/tutorial/html–primer.html*), HTML Help (*http://www.obscure.org/~jaws/htmlhelp.html*), or The Almost Complete HTML Reference (*http://www.digital-planet.com/htmlref*).

Web Browsers

The World Wide Web is accessed with programs called browsers. The browser Mosaic is to a great extent responsible for the initial explosion of the World Wide Web; Netscape has since become the standard for most users, and is responsible for the continuing expansion.

A Web browser is in reality an HTML reader. A browser reads the HTML code indicating such attributes as bold ``, a list of items ``, or links ``. Not all browsers can decode newer codes, such as those for background colors or user–input forms; and users can control some attributes, such as the size and font of the type. Thus, while all browsers can read any HTML page, any single page can look different on different browsers.

Web browsers open on a default home page. It may be the home page of your provider, the home page of the browser program, or any page that you have designated. Utilizing Hypertext Transfer Protocol, Web browsers access Web locations, follow hypertext links, and create an ongoing history of the sites visited in your travels.

Using the World Wide Web

Text-based browsers such as Lynx can be launched from public-access sites using the **telnet** command or as selections on the higher-level menus of many Gophers. Alternatively, access with

Lynx is available directly from a provider prompt. Simply type **lynx** followed by a Web address expressed in URL format:

prompt% **lynx http://thomas.loc.gov**

The command **lynx**, alone, accesses the default home page of your Internet provider.

Graphic-interface programs such as Mosaic or Netscape follow essentially the same process. Simply enter an appropriate address (or use the default site) and click on highlighted terms or icons to move from site to site. No fancy commands are necessary.

If you have used that browser before, you will have saved a list of bookmarks or hotlinks leading to your favorite sites. Alternatively, you can start from one of a number of menus, indexes, or key-word search programs.

The World Wide Web FAQ, offering discussion on both World Wide Web resources and browsers, is located at *http://www.boutell.com/faq/www_faq.html.*

The Glory and the Hype

The attention given the World Wide Web is in huge part deserved— but only in part.

Due to the added space required by fancy fonts and graphics, the text of most hypertext displays on the World Wide Web is decidedly cursory. The full opportunity for lengthy discussion is rarely taken. You find, instead, essentially an illustrated and annotated menu. Whereas a Gopher menu might offer 15 possible paths on a single screen, the opening screen of a Web site often has no more than 5 links, if that many. While many Gopher menus are complete on a single screen, a full view of most Web pages requires scanning a number of screens. These problems are clearly due in part to a lack of sophistication in writing Web pages, but the problems remain.

Content is also an issue. Many corporate home pages offer the electronic equivalent of junk mail, filled with what Bart Zeigler of the *Wall Street Journal* has descibed as "turgid company profiles, hokey product pitches and bland marketing material… that wouldn't make it from the mailbox to the kitchen counter of most homes if they arrived via the Postal Service."

Speed is another consideration. You pay for graphics with reduced speed. The text version of the opening page of the Thomas Congressional site uses 7,838 bytes of information. The opening graphic alone is another 31,280 bytes. In short, the screen with full graphics takes at least five times as long to receive. With a 14,400-baud modem, the

FIGURE 13 Thomas World Wide Web home page without graphics.

wait is annoying and at times seems interminable. The delay with animation, sound messages, or movies is even more profound. In response to this problem, new browsers load the text first, painting in pictures later, or allow you to view the screen in a text format with pictures replaced by icons (Figure 13).

Finally, anyone on the Internet can establish a home page presence on the Web. There is no committee to go through, no certification to acquire, no large investment in hardware required. Many Internet providers and on-line services now offer this opportunity to their subscribers.

The ease with which Web sites can be established has both advantages and disadvantages. On the one hand, it guarantees openness and diversity. On the other hand, the Web is subject to an overabundance of choices, many of questionable value. With broader access to the Web via on-line services, the increase in new sites has been accelerated by businesses anticipating methods for secure credit card transactions on the Internet.

Even with all the problems, in many instances the resources of the Web are without equal. For maps, product pictures, photographs, artwork, and other illustrative material, there is no substitute.

Constructing Your Own Home Page

Anyone can create a home page to use as an opening page with their browser. No programming experience is required. For help making a home page you can read How to Make a Great Home Page (*http://www.valleynet.net/~kiradive/home.html*), or complete the forms at the Home Page Generator (*http://www.cs.uoregon.edu/~jolson/generator/*.

Writing home pages is relatively simple. Getting a home page on the Internet is another matter. The easiest approach is to find a server that will carry your home page–either at your university or through your Internet service provider.

SECTION TWO

The Internet and Searching for Data

5

GENERAL WORDS ABOUT RESEARCH

Doing research in the library is one thing. Research on the Internet is something else, again. Sure there are many similarities to conducting research via an electronic network and using a modern research library, but just for the sake of argument let's look at the differences in their extremes.

Why doing research in the library may be somewhat different from using the Internet:

Library Research	Internet Research
is primarily text based	can be text, mediated or multimedia
uses standard indexes	browsers do not follow library methodology
can be done with the aid of a librarian	often is done at home without help
often starts by using familiar search tools	often starts with what's accessible
is real (as opposed to virtual)	is virtual (as opposed to real)

If you compare the two lists, you'll notice that there are some real differences in the way you research on the Internet. Up to this

point, we've talked about the many different software and hardware tools that make up the Internet. Since the Internet is a network of networks there are numerous different ways to start a search for the information you want to access, but clearly some search tools are better than others for specific purposes.

In this chapter we make a distinction between "surfing," that is, cruising the Web for information for pleasure and research for academic, informational, and/ or business purposes. We'll focus on the latter aspect here. But, before we start, you need to remember that the Internet is more than just the hardware and software connections. It is populated by people who may not always provide information in the manner that we would normally expect.

Research Starts with One or More Interesting Questions

Just as we know from our library usage, research we conduct is guided by a number of defining criteria for which we can form questions: What am I looking for? Or, where can I find information about this topic? How much material will I need for this project?

Research usually begins because we want to know something. You may seek information about a specific topic *(How much money did the ABC Television network make last year?)* or a wide range of ideas pertaining to a broad topic *(What does ethics mean to journalists?)*. Research often involves focusing on a topic and finding specific information about that topic *(Have laws helped minorities gain access to jobs in the media?)*.

We do research for many good reasons. We don't know the answer to something and we want to find out the answer. Or we have an idea that we want to inform ourselves about. We think we know the answer to a question and we want to see if it's correct. In any case, research allows us to find answers to appropriate questions.

Finally, posing a research question assumes that the information you want to know really exists, and that you can locate that information. If the information exists you'll need to know how to find out where to look, which brings us to the second point.

Research Should be Guided by Current Knowledge and Previous Experiences

The more you practice the better you become. If you are a musician you probably know that's particularly true for developing good technique. This is often true of research, too. The more research you do

the more adept you will become at doing research. And, if you know something about a topic, you often know where to look for more information. While this may seem obvious, it is not. You can waste hours researching the wrong information, hours that could be saved with a little thought about how to approach your research task before you start.

Pick an appropriate question or series of questions to start your work. Questions such as: "Why is this important?" "Who is affected by this information?" "How does this work?" are often good beginnings. If you can answer these questions, you may be well on your way to focusing your topic and developing a research strategy. Generalizing your question, if it is too specific, is as important as focusing your question when it is too broad. So, defining your research questions well is extremely important. Knowing something about what you are looking for is much better than beginning without a clue!

Discriminating Between Primary and Secondary Research Data

Once you identify the kind of information you are seeking, you are well on your way to realizing where it might be found. In addition, recognizing the sources of the information you seek provides you with a context for evaluating that research. Also, understanding the context of that information will help you determine whether the information you accumulate is of either primary or secondary importance.

Primary research is generally considered to be data directly from or related to the original source. If you were looking into what requirements a television station had to meet in order to comply with the Children's Television Act, you could read the actual rules established by the Federal Communications Commission (FCC) (*http://www.fcc.gov*) to enforce the act. This would be an example of using primary research.

You may be confused by the legal terminology or specific language used in the FCC's rules. You might not understand how the Commission determines that a station is in compliance with the requirements of the Act. If you sought out research that described or analyzed how the rules applied to television stations, that analysis would be considered **secondary** research.

Here is an important point. Secondary research is usually *interpretative;* that is, *secondary research provides analysis, opinion, or amplification of primary research.* As a researcher you need to evaluate the significance of the secondary research you acquire.

For example, suppose you found a page of information from a communications law firm that describes the FCC's enforcement requirements of the Children's Television Act as difficult to meet and possibly infringing upon the First Amendment rights of the television station owner. You might also find the home page of a public interest group that claims the FCC had not gone far enough in requiring television stations to provide adequate educational programming for children.

Both of these pages would be valid secondary sources of information, but which interpretation of the primary data, the FCC's enforcement rules, do you believe is correct? Because Internet information can be posted by anyone with access, and comes from thousands of users with differing viewpoints, the veracity of the information collected must constantly be evaluated.

Before we simply accept the information we collect, we should ask ourselves how credible the information is. If information is heresy, it may not be very useful for our work. Researchers frequently develop a standard for accepting contributing or secondary information; that is, they might require affirmation of several secondary sources before they decide the information is valid.

We can generalize about what is primary and secondary research. Again, generalizations help us develop a sense of what is important and what is not.

Examples of primary information are:

- original manuscripts, scripts, works of literature, lyrics, songs, films, videos
- laws or statutes, hearings, official statements and testimony, trial transcripts
- direct quotes from authors or individuals involved in the topic
- data collected by independent researchers about a research question
 (e.g. results of scientific studies, data collection, surveys, etc.)
- direct quotes from eyewitnesses

Examples of secondary information are:

- criticism about works of literature, art, music, etc.
- analysis and/ or commentary of laws, scientific studies, data, surveys

- commentary about issues, works of art, literature
- opinions or summaries about issues or events
- edited quotes from newspapers, magazines, television programs

Questions about how much importance you should place on interpretive data are sometimes difficult to answer. Try to develop a research strategy for finding the answer to this question below. As you read through this scenario try to determine whether the various possible sources are secondary or primary in importance.

> You are looking into why your favorite television show was canceled by a television network. Suppose that you searched the homepage of the show's star and read that the actress had decided to take a break from the rigors of acting in a weekly television show after three successful seasons. Such a statement makes sense and might be a perfectly legitimate reason for leaving the show.

> However, you also found an article from the Cybertimes sections of the New York Times on-line that quoted the vice-president of the XYZ television network who said that they had canceled the show, even though it had several successful seasons, because the show wasn't attracting the right audience demographics necessary to appeal to advertisers. Which explanation would you believe?

> It is possible that several conflicting reasons might be found that detail the reason for the demise of the show. How can you be sure you have the right answer or that there is one reason for the show's cancellation? You could search for corroboration: are there are sources that lend credibility to either of the first two sources you've located? What sources of information might you use to determine the reason the show was canceled?

A Research Model Driven by What You Know and What You Don't

Research is not just discovery; gathering useful research requires you to discriminate between what is important and what is not. After some time you must join important bits of information together. Let's use the example of FCC rules again.

Frequently people are scared off by the "legal" sounding language of the FCC rules, believing that Commission rules and regulations (as they are called) are just too difficult for a layperson to un-

derstand. Many are surprised to find out that they can understand the information contained in FCC documents by researching some general secondary information about the subject first before they attempt to understand the primary material. So, it is often easier to start researching secondary sources before primary sources.

The point here is to start the learning about your topic as quickly as possible. As you gain information about your topic you are better able to evaluate the usefulness of the next bits of research you collect. Frequently, as you search, you'll discover new areas of interest that may allow you to better focus or refocus your work. The Internet is a wonderful resource for finding information, and it can serve as an excellent start for finding secondary sources. We'll discuss this in greater detail in this chapter.

THE INTERNET: GUIDELINES FOR DEVELOPING ELECTRONIC SEARCHES

The Internet is constantly changing; it is bigger today than yesterday, bigger than its creators ever envisioned. Everyday new resources are added, giving us access to new information. Information resources that were costly or unavailable just a year ago are now readily accessible to the Internet user. Databases that were available only to private subscribers are now available for a fee to Internet users, usually by using one of the several credit methods available for electronic commerce. However, before you can just start searching, you'll have to have some idea what's on the Internet and how to access it.

Knowing where to look depends on knowing where you should look. A number of electronic resources can provide you with general and specific information. This text is primarily concerned with subjects related to electronic media, but that covers a tremendous area. Some of the various search areas include:

abstract services

anonymous FTP software archives

databases (both public and commercial)

nonprofit organizations

on-line library collections

professional associations

special collections

state and government agencies

usenet newsgroups and listserv discussion groups

Knowing What You Can Get and How to Get It

Knowing what is available on line, and where, is really just the beginning of effective Internet searching. There are numerous services available and you need to know where they are and how to access them. Some of the services use specific programs while many others can be accessed via the World Wide Web. Some services are free; others require that you pay a fee.

To use all of the various services, you'll need to understand how each service organizes and accesses information, when you should use Veronica instead of a World Wide Web search program, and whether a particular search program accepts Boolean logic in its search terms. Knowing this information will save you valuable time and enhance your searching capabilities.

The Services of the Internet

As we noted previously, each service of the Internet accesses different search tools or resources. Many of the services serve different purposes, and some overlap in what they will retrieve. Which you choose and how useful each tool will be depends on the kind of information you need to search for.

E-mail

Internet e-mail is like an electronic post office. It is useful for contacting people or participating in discussion groups, or as a listserv that send posts to your e-mail account. You can contact specific people, post a message to a discussion group or newsgroup, or use the broadcast feature to send messages to a number of different people simultaneously.

As we noted earlier, there is no common directory to the Internet. As a result, e-mail is limited to those addresses you know or can access. Here's a brief illustration to show you how difficult that might be.

WHAT'S THE BIG DEAL IN FINDING AN E-MAIL ADDRESS?

Consider the task of finding an e-mail address that you don't know. Say, for example, you want to send an e-mail message to the Vice

President of the United States to tell him you approve of free Internet access for all students. You would have to know Vice President Gore's e-mail address. You'll note that we said that there was no one official Internet directory that listed every e-mail user's address. You could try to locate an address by using the Knowbot Information Service (KIS), based at the Internet Society headquarters in Virginia (*telnet info.cnri.reston.va.us 185*). However, when we used that search method we found the search directories were unable to locate Gore's e-mail address.

Using the World Wide Web, we were able to locate his e-mail (*vice.president@whitehouse.gov*) address by accessing information from the pages of *The Electronic Activist* (*http://www.bershire.net/~iafs/activist/*) and from *NYnet E-Mail Directory* (*http://soho.ios.com/~nynet/email.html*), which has a number of hard to find e-mail addresses listed.

Gopher allowed us to reach the Yale University collection of e-mail directory resources (*telnet://de@hypatia.umdc.umu.se/*). Through the Yale link, we logged onto *Netfind* at the University of Colorado and searched the database for Al Gore; we found addresses for the Clinton/ Gore Re-Election Committee but not for the Vice President.

Four-11 white pages (*http://www.four11.com/*) has a directory of e-mail, netphone, and telephone numbers, but it is not a complete directory. Another option that will be available is the *World-Wide E-Mail Address Book*. It is supposed to start up sometime during the summer.

There are numerous specific directories available which you can find using a web search engine. You can find e-mail directories for Great Britain, Australia and New Zealand by doing a web search and asking for "e-mail directories (country name)." We have no idea how complete or up-to-date these directories really are.

Many universities, government agencies, and businesses maintain an e-mail directory of their constituents. You can log on to these home pages and search for directories. Sometimes the simplest solution is the best; you can call the individual and ask for his/her e-mail address. *Switchboard* (*http://www.switchboard.com/*) offers a comprehensive on-line directory of telephone numbers and addresses. The long and short of this illustration is to point to the fact that the Internet is comprised of networks of information posted by people for specific reasons. There are many gaps in the information that can be obtained. An important consideration when you rely too heavily on it for your research.

Listserv/Discussion Groups

If you wish to locate individuals as representatives of an organization or sharing a specific interest, listserv discussion groups may be appropriate. Chapter three discusses how to search for newsgroups using a keyword or a concept. There are hundreds of different groups.

Usenet/Newsgroups

If you seek current discussion of a particular topic or issue, or to identify individuals with a specific interest, newsgroups can provide you with one or more groups on almost any topic imaginable. Clarinet is a news service attached to Usenet that provides current news. However, Clarinet charges a site fee to the Internet service provider, so you may not have access to that information. You can determine if your site gets Clarinet because the Usenet prefix is Clari.

Newsgroups on some programs, like NetCom, are listed in alphabetical order. The prefix gives you an indication of the subject matter. Here are a few examples:

Prefix	Subject Area
alt	Alternative newsgroup
biz	Business
comp	Computers
rec	Recreational topics
sci	Science

Thousands of different newsgroups exist for practically any subject you can imagine. Here is a sampling we put together of a few of the many newsgroups relating to electronic media. It is easy to determine the subject matter based on the newsgroup title.

alt.animation.warner-bros	alt.tv.game-shows
alt.art.video	alt.video.avid-editors
alt.binaries.multimedia.d	alt.zines
alt.binaries.sounds.cartoons	aus.radio.broadcast
alt.cable-tv.re-regulate	clari.biz.industry.media. entertainmet
alt.comedy.slapstick.3-stooges	clari.tw.telecom.phone_service
alt.conspiracy.jfk.moderated	comp.graphics.animation
alt.cyberspace	comp.sys.sgi.graphics

alt.fan.howard-stern	de.comm.infosystems.www.browsers
alt.games.video.coming-soon	fj.rec.music.classical
alt.internet.talk-radio	law.school.copyright
alt.journalism.criticism	misc.news.internet.announce
alt.movies.hitchcock	rec.arts.disney.animation
alt.music.blues-traveler	rec.arts.movies.current-films
alt.news-media	rec.arts.sf.tv
alt.radio.college	rec.arts.tv.soaps.abc
alt.satellite.tv.europe	rec.photo.technique.art
alt.shared-reality.x-files	rec.radio.broadcasting

There is tremendous power in these newsgroups. In them lie years and years of collective discussion concerning these topics. They are also an instant source for advice, perhaps conjecture at times but more often than not, expert opinion you could not buy. You can search Usenet newsgroups by using Dejanews Research Service (http://www.dejanews.com/). Harley Hahn (A Student's Guide to UNIX) calls Usenet the "largest information utility in existence." Check it out!

FTP/Archie

In Chapter 4 we likened Archie to the library card catalog. Actually that's a pretty good analogy, because like a card catalog Archie scans the titles (names) of FTP files and displays the results of that search.

Archie has two features that make it a useful search tool; its data gathering feature automates the gathering, indexing of information, which has made it easier for information providers to provide resource discovery and access to information while the user access features allow you to locate and access your information using a variety of interfaces and search methods.

Current commercial versions of Archie have gateways built into them for a number of other Internet information systems, including the Wide Area Information System (WAIS), Gopher and the World Wide Web (W3). So, if you seek specific computer files, file transfer protocol would be the obvious starting point, and Archie would be a useful tool to find specific files.

Here are the first few responses of an Archie search on the term "broadcasting" that yielded more than 80 different file outputs. You'll

note that these files contain Internet addreses which make them easy to retrieve using a browsing tool.

From: (Archie Server)archie-errors@ds1.internic.net

Reply-To: (Archie Server)archie-errors@ds1.internic.net

Date: Wed, 19 Jun 96 23:16 -0500

Subject: archie [prog broadcasting] part 1 of 1

Host ftp.hk.super.net (202.14.67.233)

Last updated 10:35 19 Jun 1996

Location: /.3/news.answer/radio

DIRECTORY drwxr-xr-x 512 bytes 13:53 27 Oct 1995 broadcasting

Host ftp.bhp.com.au (192.83.224.131)

Last updated 10:17 19 Jun 1996

Location: /internet/FAQs/alt.answers/radio

DIRECTORY drwxr-xr-x 31 bytes 06:46 11 Nov 1995 broadcasting

Location: /internet/FAQs/news.answers/radio

DIRECTORY drwxr-xr-x 31 bytes 23:43 10 Nov 1995 broadcasting

Host ftp.uwo.ca (129.100.3.24)

Last updated 10:19 3 Jun 1996

Location: /doc/FAQ/radio

DIRECTORY drwxr-xr-x 512 bytes 23:26 5 Feb 1996 broadcasting

Gopher/Veronica

The search program Veronica helps to locate documents, files, information, or data from or about a specific education, governmental or non-profit organization or association listed on a Gopher server. Veronica can be of service here, as well as for just about any academic, governmental, or computer related topic.

WAIS

If you are seeking the contents of academic or government documents or databases, WAIS may be a good tool to utilize. WAIS differs from Archie in that it searches the entire text of a document for terms instead of just the file name or title. This extended search capability is very useful because it is somewhat similar to executing a "keyword" search in the entire file.

Because WAIS searches for keywords within an entire document, you need to be careful to use terms specific to your research. Too broad a search is likely to result in the display of a large number of documents that may only be superficially related to your interest area.

World Wide Web

We think that the World Wide Web is the most direct source to locate information on the Internet. So, why have we listed it last? The graphical interface and the server space required to run World Wide Web has precluded some colleges from offering access to it either through dial-up or in public terminal areas. However, that is changing rapidly, and if you have access to the Web, your searching will be greatly simplified and enhanced. It's simply a matter of pointing and clicking.

Today, as more and more commercial companies gain a presence on-line, the Web is particularly useful to get product information and technical assistance. And the Web is the choice for multimedia presentations. As you'll discover in the next chapter advances in programming techniques and browser capabilities are making the integration of sound, movies and animated graphics easier to display and utilize.

Finally, remember that many World Wide Web search programs include access to the other search tools we've discussed in this chapter. You can download files from FTP sites and use Gopher or Archie to locate files and databases. When you consider how this integration of search tools increases your chances of locating information quickly, the Web becomes most attractive.

A Simple Strategy for Using On-line Time

If you were paying a per-minute charge for accessing the Internet, you would probably want to get on, do your search as quickly as possible, and get off. This strategy would minimize your research costs. Though most users pay for access by the hour or get access for minimal cost, the same general rule for efficient use of the Internet should prevail.

To best use your time, know what you're looking for beforehand and have a plan for accessing it. Get the information you seek and log off, especially if you are paying hourly expenses imposed by on-line services or Internet providers.

One strategy that can save time and money is to download information for later perusal. Off-line time is cheaper than on-line time,

hard copies are easier to read than text on screens, and you can make notes about what you feel is important. Both text and graphic-interface programs offer some means of automatically capturing on-screen text during a session. You can save hypertext pages on the World Wide Web in a cache directory for closer examination off-line.

Spend your time on-line evaluating information, not just look-ing up addresses. Many software programs allow you to maintain directories of sites for FTP, Gopher and WAIS programs. If this is not possible, keep a log of addresses handy. Use bookmarks for sites you visit frequently on the World Wide Web and on Gopher.

A Word of Caution About Plagiarism

Downloading documents instead of finding published texts and photo-copying them can save you time and money. Word processors allow you to insert that text directly into your own writing, and this feature is both handy and a real time-saver.

However, along with the ease of integrating materials into your work comes the danger of confusing your text with material that you have downloaded, and in so doing, plagiarizing material that rightly belongs to another. Without taking adequate precautions it is possi-ble to lose track of information.

Develop a unique way of storing and downloading information; maybe using italics or a special font can help serve as a reminder that you need to cite material as you incorporate it into your work. What ever you decide to do, be consistent so that you won't acciden-tally lose track of your citations.

Because the use of the Internet as a major research source is still relatively new, determining how to cite material located on-line is problematic. There are many good resources on the World Wide Web that describe acceptable means of citing Internet works. Here are a few that we've found particularly useful. Some of these works are style sheets while others are complete discussions about what and how to cite information. We've listed sites for both MLA and APA users.

Scholarly Citations of Internet Sources
http://garnet.berkeley.edu:4252/Scholarly_Citations.html

A Style Sheet for Internet Sources: MLA Style
http://www.lib.berkeley.edu/TeachingLib/Guides/Internet/MLA
StyleSheet.html

Citing Sources (For Academic Papers)
http://www.indiana.edu/~wts/wts/citing.html

Using APA Sources
http://fur.rscc.cc.tn.us/OWL/UsingSources_APA.html

Electronic Sources:APA Style Citation
http://www.uvm.edu/~xli/reference/apa.html

INTERNET RESEARCH RESOURCES

Desk Reference Tools

The Internet offers various electronic versions of standard reference works. Whether you're interested in standard encyclopedias or specialized dictionaries, it is likely you'll find a reference work to help you. We've listed some places that offer a wide assortment of reference works.

While many universities offer menus of basic desk reference tools on Gopher or the World Wide Web, perhaps the most complete and useful is Desktop References at MIT (*http://www.ll.mit.edu/ComLinks/deskref.html*). Almost every imaginable general subject heading has a hypertext link to reference sources. For copyright reasons, links with asterisks are available only to members of the MIT community, but there is an incredible amount of material available for the general user.

Another great general reference is The On-line Reference Desk (*http://www.sil.org/general/reference.html*) sponsored by the International Linguistics Center. This site has one of the most complete Web reference sections available with links to such diverse references as *Elements of Style, Roget's Thesaurus, U.S. Gazetteer, The World Factbook 1995, 1995 Statistical Abstract, West's Law Dictionary,* and *The Free Internet Encyclopedia* to name a few sources.

Planet Earth's Home Page of Books and Libraries (*http://www.nosc.mil/planet_earth/info.html*), perhaps the most global of the sources listed here, features access to Encyclopedia Smithsonian along with numerous other links to standard reference works.

Of course, there are many other general and specific reference links available on the Internet. You can search for them using one of the web browsers or by doing a Gopher search.

Using Browsers as Subject Guides

Using comprehensive subject guides, such as the ones described below, is an excellent way to begin a subject search. These browsers

have different features and capabilities. This list is not all inclusive, but it will help you get started.

Infoseek (*http://www2.infoseek.com/*)
Broadly based search engine that allows you to switch from WWW to other databases. Has a good categorical structure plus searching tips.

Open Text (*http://www.opentext.com/omw/f-omw.html*)
Excellent catalog search capabilities that provides links to text, graphics, sounds, and videos.

Starting Point (*http://ds.internic.net/cgi-bin/enthtml/ business/starting-point.b*)
A browser that allows you to search by broad categories or to refine searches. Easy to use and good for locating secondary sources of information.

YAHOO! (*http://www.yahoo.com/*)
A very useful search engine that allows you to browse and search subject categories. Output is hyperlinked by categories for ease of use.

Key-Word Search Programs

If you have no idea where to start, you might try a key-word search program. Key-word search programs are useful for finding unique names, places (proper nouns) or specific terminology for which there would be no likely synonym. They are not as useful for general terms, you would be better off using one of the categorical search engines described above.

Major key-word search programs include:

AltaVista (*http://www.altavista.digital.com*)

Excite (*http://www.excite.com*)

Magellan (*http://www.mckinley.com/*)

Yahoo Search (*http://www.yahoo.com*)

Lycos Search (*http://www.lycos.com*)

Dejanews Research Service (*http:llwww.dejanews.com/*)

As we stated before, no search program searches all of the Internet. Different search programs search different databases, or search the same ones differently. Some search titles, others scan the documents, still others search other indexes or directories. Some will give you an option to include searching on Newsgroups. Some search the URLs describing the location of a text, others the URLs embedded within hypertext pages.

After you try the various search engines, you'll get a feel for the way they work, how they differ, and what the advantages are for the different search techniques.

The important thing to remember is that no one search tool will give you all of the possible sources of information on the Internet.

This chapter has described many tools for you to use to conduct a successful search on-line. Which resources you use depend on what you think will be most helpful in locating information for your research topic. However, we think that with a bit of experimentation you'll discover the various strengths of the many tools described here.

We're so confident that you're ready to begin that we suggest you start with a little competitive fun. Try playing *The Internet Hunt* at FTP site *ftp.cic.net in the /pub/hunt/ directory*. This game consists of a list of questions whose answers are available somewhere on the Internet. Look at previous games archived; they'll give you a good idea of the wealth of different information available on-line. Good Hunting!

A Final Word

When you read The New York Times you have a certain idea of its reliability; you probably have an opinion about the veracity of *The National Enquirer*, too.

A book or professional journal in a research library has been selected from among competing texts and subjected to a peer review process prior to publication. Librarians trained in specific academic disciplines choose books and periodicals for inclusion in the library collection. The title and copyright page tell the true author, place, and date of publication. There is little doubt that the material located under these circumstances is reliable.

With the Internet, none of these assumptions may be accurate. There are no master librarians on-line to check whether the material posted is fact or fiction.

Internet data is no more authoritative than any other. Thus we must take care in assessing how valuable and useful the information we retrieve actually is. "Anyone who has attempted to obtain information from the internet" an editorial in the *Journal of Chemical Education* observed, "knows that you are as likely to find garbage as you are to find quality information."

As we stated earlier, the Internet is a network of networks, populated by people who can make available what ever information they choose. While the Internet may have the richness of global information, as the potential consumer, you need to be careful about what you accept as the truth. Caveat emptor!

The Internet as the Future of Wired Communication

6

MAKING SENSE OF THE CHANGING SOFTWARE SCENE IN MULTIMEDIA

This chapter looks at some of the newest innovations taking place on the Internet. Changes in software and network hardware, along with the new generation of faster home PCs have allowed producers of Internet information to implement exciting changes in the way information is being presented. In the last year we've seen many multimeda innovations introduced on the Internet. We'll look at some of the newest developments and discuss their potential.

Those Who Sounded First: Progressive Network's RealAudio

In the spring of 1995 Progressive Networks shipped RealAudio, their proprietary client based audio solution that delivers real-time audio on the Internet (http://www.realaudio.com). There was audio on the Internet before RealAudio, but it required waiting for the download time. For example, a highly compressed low resolution one-minute file could take three to four minutes on a 28.8k modem; the wait hardly seemed worth it. Now, all it takes is a slight delay when connecting the sound. Another advantage to this method is that there is no actual data taking up space on your hard disk and all that is required for connecting is a 14.4k modem. RealAudio is capable of

scaling its fidelity up on a higher speed connection. With a 28.8k modem you can expect nearly the same sound quality as mono FM.

While standards are still unresolved, Progressive delivered a successful solution to real-time audio on the Internet. To back it up, they quickly aligned themselves with the partners that could deliver content to make RealAudio useful. Numerous sites including NPR (*http://www.npr.org*), ABC Radio Networks (*http://www.abcradionet.com*), and CBS Radio Networks (*http://www.cbsradio.com*), quickly established RealAudio servers to deliver their programs to you on the Web. Without these major contributors and an easy way for users to create their own audio works, RealAudio and the subsequent players would have served no real purpose at all. In its first year of release, Progressive claims to have shipped over four million players with 25,000 downloads a day from their site. Now operating as a plug-in and shipping with popular browsers, RealAudio has established itself as a de facto standard.

A fundamental attraction of RealAudio is that it delivers its magic exclusively through software. No dedicated hardware or encoding card is required to "transmit" or receive their audio files and it's free for the download.

There are now several other audio players and plug-ins available, and each of them has taken a slightly different approach in the way they compress and deliver the signal. Ultimately, however, as far as the end user is concerned, what matters most is whether the programming you are interested in is available in a certain format and whichever works best with your set up.

Other players that are distributed include: Xing Technology's Streamworks. Streamworks uses MPEG compression and it is capable of delivering both audio and video in a streaming fashion on a 28.8 connection.

Along with Streamworks, CU-SeeMe and RealAudio, there are several other streaming audio products available for downloading. One is VDOLive (*http://www.vdo.net*) making both Windows and Macintosh operating systems well represented. The DSP Group's TrueSpeech (*http://www.dspg.com/plugin.htm*) and VocalTec's Internet Wave (*http://www.vocaltec.com/products.htm*) are also available, but for Windows only.

The First Radio on the Web

Predating the release of RealAudio, in October of 1994 WXYC of the University of North Carolina at Chapel Hill (*http://sunsite.unc.edu/wxyc/simulcast/index.html*) began publicly simulcasting its off-air signal to the world on the Internet. Believed to be the first station in

the world to transmit on the Internet, they accomplished this through the use of the software, CU-SeeMe. WXYC now uses Xing Technology's Streamworks, which is also available as a player at: (*http://www.xingtech.com*).

The University of Kansas's School of Journalism and Mass Communication, radio station, KJHK is also simulcasting their broadcast (*http://www.cc.ukans.edu/~kjhknet/index.html*), as is Radio Korea (*http://www.radiokorea.com/ram/live.ram*). It's only a matter of time before the multitudes of enterprising student stations make their signal available to the world. Receiving KJHK broadcasts requires either having CU-SeeMe (*http://cu-seeme.cornell.edu*), or Enhanced CU-SeeMe from White Pine Software (*http://www.cu-seeme.com*) installed. Internet Phone will also allow you to receive this station and from their own reports it is the best application when on a 28.8k modem.

To receive programming from any of these sources we recommend double checking their requirements on their Web site (*http://www.cc.ukans.edu/~kjhknet/index.html*), where usually the process is clearly laid out for you. At the time of this publication you could receive KJHK's broadcasts by placing an Internet Phone call to their IP 129.237.245.120 or start up CU-SeeMe and pulling down the Conference Menu and Select Connect To there in the IP number field, enter 129.237.117.94. A 30-day trial of Vocaltec's Internet Phone is available from (http://www.vocaltec.com).

An Audio Network on the Internet

One server that offers a substantial representation of programming is AudioNet (*http://www.audionet.com*). AudioNet launched in September of 1995 with sports only broadcasting. AudioNet claims to have been the first audio network on the Internet. Their cybercasts now offer a wide range of specialty programming, including live talk radio and archives of radio programming from numerous other sources.

While much of this programming is already available on the radio, the Internet crosses all geographic and demographic boundaries, offering a tremendous level of diversity 24 hours a day. It is truly the first on-demand medium.

Phone on the Internet

The next link in the electronic media chain on the Internet brings us to two-way voice communications or Voice On the Internet (VON). An ample selection of software for each of the platforms exists; we

will introduce several of them here to get you started. To get started we recommend visiting the MIT's Research Program on Communications Policy's (RPCP) Home Page (*http://rpcp.mit.edu*). There you will find a tremendous resource, links organized within these areas: Reports and Publications, The Cambridge Roundtable,The Digital Information Infrastructure Guide (DIIG), Networked Multimedia Information Services (NMIS), Workshops and Seminars and Profiles of RPCP Group Members. Also on this Web site is Andrew Sears' Internet Telephony Page (*http://rpcp.mit.edu/~asears/main.html*) where you can read the FAQ, "How do I use the Internet as a telephone." Andrew is currently a graduate student at the RPCP and is establishing MIT's Internet Telephony Interoperability Project. This site will serve as a great introduction and it will point you in the direction of a tremendous number of resources.

Web-based publications such as C|NET (*http://www.cnet.com*) serve as an excellent resource to become familiar with new applications and trends. Frequently you will find product reviews such as, "12 Web phones to make Net calls" (*http://www.cnet.com/Content/Reviews/Compare/Wphone*) by Michael Mathog and Eric Knorr in C|NET, where Web phones are examined in detail. This article and lots of others on the Web will link you to vendors and demonstration or trial versions of their programs.

While standards are not yet established, a common method of compression and transport protocol is Groupe Speciale Mobile (Global Standard for Mobile Communications), or GSM. If a program uses a proprietary encoding method you'll only be able to communicate with someone with that exact program. For a look at some technical details, code libraries and further links on GSM look at Jutta Degener's GSM 06.10 lossy speech compression page at (*http://www.cs.tu-berlin.de/~jutta/toast.html*). The subtitle for this page is, "how to squeeze one second of human speech into 50 33-byte frames." If you've gone this far, then you might as well look at Jutta's actual homepage (*http://kbs.cs.tu-berlin.de/~jutta/index.html*) titled "the boggle reaction." We found some real fun audio oriented links there. Jutta is a student at TU Berlin.

The introduction of voice transmissions on the Internet hasn't evolved without controversy. In the US, the Federal Communications Commission (FCC) (*http://www.fcc.gov/csb.html*) and state Public Utility Commissions (PUC) have been asked by long-distance telephone companies to outlaw or at the very least, introduce regulation for Internet telephony software. These companies argue that introducing VON applications makes these developers "Telecommunications Carriers."

As the titans collide and attempt to influence policy, turbulent times lie ahead as each industry tries to make its technology the standard. On one side there are the benefactors of the age-old regulated telephone monopoly and on the other is the third largest industry in the world: the competition-driven PC business, where standards are open to any company capable of implementing the technology. To further complicate this, some Netizens (citizens of the Net) feel that voice dissipates too much of the Internet's transmission pipeline, or "bandwidth ," causing all other communications to bog down.

With the continued explosion of new users coming onto the Internet, bandwidth is clearly an issue; without question it is not something to be wasted frivolously: with demand increases and evolving technology the pipeline will most certainly increase. For now, though, please use it wisely.

Here are several of the most popular of the telephony products.

CU-SeeMe (*http://cu-seeme.cornell.edu*)
A multipurpose utility software program available for both Mac and Windows was developed at Cornell University where it originated as a video only conferencing application. Maven, an audio only program, was later incorporated into CU-SeeMe to process audio. We will address CU-SeeMe in greater detail in our section on Software Teleconferencing. The original CU-SeeMe is still available free but there is also a commercial product, Enhanced CU-SeeMe (http://www.cu-seeme.com) from White Pine Software which is available for a thirty day trial. CU-SeeMe is very clever in its design and it is an extremely powerful application. Part of its power is having the ability to serve different needs in various configurations. With only a microphone connected to the computer it operates with audio only; plug a video camera into an A/V computer's port and the video transmission is enabled.

WebTalk (*http://arachnid.qdeck.com/qdeck/products/webtalk*)
Quarterdeck's critically acclaimed WebTalk shipped first for Windows but is expected to be available for the Mac.

Internet Phone (*http://www.vocaltec.com*)
A 30-day working trial of Vocaltec's Internet Phone is available here for both Mac and Windows. There is also a listserv available by sending:
"subscribe iphone" to majordomo@pulver.com.

PGPfone (*http://web.mit.edu/network/pgpfone*)
Developed by Philip Zimmerman of PGP (Pretty Good Privacy)

encryption fame, PGPfone is available for Windows and Mac. Through the integration of PGP's encryption code, PGPfone provides a truly private conversation.

Any of these solutions will get you connected to another user with similar software. Typically a public address is included in the program's "phonebook," making it easy to try by connecting with someone else who is currently on and using the software. In general the audio fidelity is comparable to AM radio quality, not quite as clear as voice quality on a telephone.

Software-based Teleconferencing

Picturetel
Largely because of its orientation in television news gathering, transmitting video and audio appears to be a trivial task to even the uninitiated. Video teleconferencing has made great advances in a short time, but the issues surrounding it are anything but trivial. Its advantages are numerous and it affords the opportunity for the personal aspects of a face-to-face meeting without the expense and inconvenience of travel. The need for videoconferencing has grown to where it is now available at 150 Kinkos copy centers throughout the world.

A leading developer and early entry into the implementation of videoconferencing is PictureTel (*http://www.pictel.com*). A high-end PictureTel system includes a high resolution camera, and a dedicated computer that digitizes, compresses and decompresses video and audio and transmits its digital signal "point-to-point." In this case point-to-point simply means another PictureTel unit that receives and decompresses the signal on a telephone line capable of handling higher throughput; typically the line is ISDN (Integrated Services Digital Network).

ISDN and Compression
ISDN is an international standard that makes it possible to send and receive voice, video, and data simultaneously over a digital phone line, and it is affordable. An ISDN in North America is capable of sending 128 Kbps (kb per second), nearly five times the capacity of a standard 28.8 Kbps modem. While 128 Kbps sounds like a lot of capability, it really is only a fraction of the information needed to send a full-motion video picture. To demonstrate this, let's calculate how much bandwidth video requires. Video displays are always smaller in a desktop conference because the simplest method of compression is to throw out part of the information, so instead of a

full-screen image (640x480 pixels), we shrink the picture down to a fraction of its size (160x120 pixels).

Because video pictures are made up of dots or pixels we can generalize and say each pixel represents one byte of data–if we multiply the 160 x 120 screen size, we now know that the 120x160 frame totals 19,200 pixels (or 19.2 kilobytes, written 19.2k). Keep in mind that this is just one single frame of video–in order to be in motion we would have to send 30 of these frames sequentially every second. The sequential transmission of 30 video frames per second is called "real-time" and as you can see it would require tremendous bandwidth (19,200k x 30 frames = 576,000k of info per second). Just one second of full motion video exceeds ISDN capacity (128Kbps) by nearly a factor of four! There is just no way we can squeeze enough video down our pipeline without compressing the video frame.

There are several compression methods and standards available. JPEG is the most widely used and enables the user to set how much compression, or loss of picture quality should occur. Compression ratios for transmitting video of 1 to 10 (1:10) are acceptable, so if we take our single frame of video (19.2 kps) and apply a 1:10 compression it becomes 1.9 Kbps (x 30) = 57 Kbps. So, through compression it is possible to send full-motion video through an ISDN line, but remember, this is video that would only be a fraction of a full screen.

ISDN for business and residential use is increasingly available from your local telephone carrier. Take a look at NYNEX's Web site (*http://www.nynex.com/isdn/isdn.html*) for more details on ISDN. While this is more relevant to NYNEX subscribers, a recent search on "ISDN in the US" on the Web returned a significant number of the US RBOCs' Web sites where their ISDN information is detailed.

Desktop Conferencing

PictureTel, among others including Intel, Creative Labs, and Compression Labs have developed desktop conferencing products that cost significantly less than the dedicated PictureTel units. So, through compression it is possible to send full-motion video through an ISDN line, though only a fraction of a full screen. Desktop products are available on all platforms and start at as little as $900. These operate on any multimedia PC with a network connection and a video camera.

As we see from our exercise, video means substantially more data to push into the pipeline, so adding audio to that means even more for the software to compress. Consequently, the quality of the streaming video is not great, at least on a 28.8k modem; it can't be. When the connection speed is slow, as it is on a modem, the video

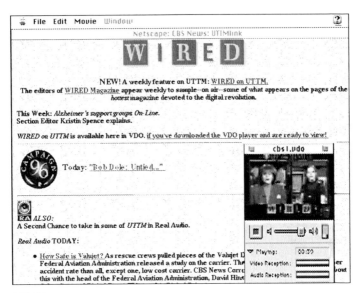

FIGURE 14 VDOnet's VDOLive and RealAudio are used by UTTM/
CBS News to deliver special weekly programs from
Wired magazine.

may appear jerky and the audio is likely to be out of sync. With suffi-
ciently more throughput available on a local network (LAN), where
Ethernet is the common pipeline, two-way videoconferencing is be-
coming an "intranet" application gaining in popularity.

Streaming Video

Despite current limitations in bandwidth, several developers have
made it possible to receive small streaming frames of video on a
28.8k modem connection. Each of these handle the compression,
hence the image, in a slightly different way. A sampling of current
players available are: Xing's StreamWorks and Xing MPEG
(*http://streams.xingtech.com*), VDOnet's VDOLive (*http://www.vdo.net*),
and two plug-ins for the Netscape browser, InterVu's MPEG Player
(*http://www.intervu.com*) and Vivo's VivoActive (*http://www.vivo.com*)
in partnership with PictureTel..

If you were unable to attend NAB '96 and NAB MultiMedia World
you could have opted to view video highlights and still can at VDO-
Live's Gallery (*http://www.vdo.net/products/vdolive/gallery/*). Bill
Gates's keynote presentation at the Microsoft Developer Conference in
San Francisco was also available at this site and might still be there.

While the video's clarity and detail are a problem, streaming video is in its infancy, and for some situations it does the job. As far as motion is concerned, a 28.8k connection with these players will range from just a few 120x160 frames a second to 10 frames or more. On a 28.8 we had the best luck with VDOLive and Streamworks. InterVu's player introduces an interesting concept of previewing while the MPEG file downloads, but we found the streaming unbearably slow at this speed. Clearly some programs do a better job in compressing on their end and decompressing on ours than others.

CU-SeeMe

The first and what is believed to be the most widely installed two-way conferencing program exists in two versions, CU-SeeMe (*http://cu-seeme.cornell.edu*) and Enhanced CU-SeeMe (*http://www.cu-seeme.com*). This program presents an ingenious way of transmitting video and audio. Rather than having to digitize and post-compress the video, which can take a great deal of time, CU-SeeMe enables a connection with a live camera or VCR and sends the video and audio at whatever frame rate the connection permits. In essence, it operates on-the-fly. So, on an intranet, the video and audio will play at significantly higher frame rates than on the Internet. This represents a scalable solution, one that scales up or down to the capacity the line is capable of. It does a surprising job with a 28.8 connection.

CU-SeeMe originated with sixteen shades of gray, very small video displays without audio. Now, as a licensed commercial version, Enhanced CU-SeeMe fully supports color with a good latitude of compression choices and it ships with WhitePineBoard. WhitePineBoard is a "whiteboard" software program that enables multiple users on a network, or the Internet, to view, interact and chat about a project. Whiteboarding is very exciting because it enables interaction among a group of users when face-to-face isn't necessary but demands far less bandwidth than audio and video.

For technical questions concerning CU-SeeMe visit Michael Sattler (*http://www.indstate.edu/msattler/sci-tech/comp/CU-SeeMe/index.html*) and Bill Woodland's Undernet IRC #CU-SeeMe Info Page, (*http://www.realtime.net/~wcw*).

Teleconferencing Cameras

There are a number of small high resolution cameras that enable transmitting video and sound on an intranet or the Internet.

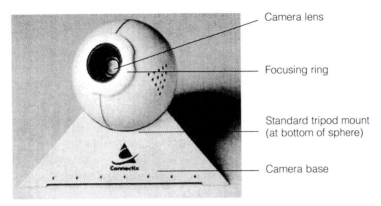

Camera lens

Focusing ring

Standard tripod mount
(at bottom of sphere)

Camera base

FIGURE 15 Connectix QuickCam is designed to sit on the top
of a monitor

Extremely affordable and well regarded solutions are Connec-
tix's two models of Quickcams (*http://www.connectix.com*). Two oth-
ers offered early desktop teleconferencing cameras: Howard Enter-
prises' HA5400 (*http://www.howent.com*) and VideoLabs' Flexcam
(*http://www.flexcam.com*), each part of a larger line of desktop cam-
era products. They are a bit higher in price and additional hardware
must be purchased for the camera to digitize. Any video camera can
actually be used as long as video capture capability is possible.

If your budget is tight, one of Connectix's Quickcam is really
hard to beat: the grayscale model or a 24-bit capable color digital
video camera that plugs directly into the computer's serial port.
This model requires no additional hardware and is very nicely de-
signed. Each unit is complete out of the package with a base that
allows it to sit on top of your monitor. There is also a standard tripod
mount, making it possible to mount anywhere. One reason for its
low price is that it does operate better when used with a higher-end
computer with a fast online connection. The Quickcam is extraordi-
narily simple to use, with only two connections to make. It was up
and running in less than five minutes and on the first try it worked.
It is truly a plug-and-play solution that shouldn't be overlooked if
you are in this price range.

Connectix uses a proprietary compression technology called
VIDEC (Video Digitally Enhanced Compression), which is a 4:1 ratio
and capable of good picture quality.

Future Lab has been shipping Flexcams for a number of years;
a major difference is that you need a capture or digitizing board or
an A/V Macintosh to get the video into the computer.

Things are evolving at lightning speed, and it is predictable that video and audio will be more closely integrated into Netscape and Microsoft's browsers. Netscape and Microsoft have already made announcements for their "LiveVideo" and "ActiveX" specifications. With compression algorithms getting better, multimedia data rates will increase and it seems inevitable that larger bandwidths will be offered by sources such as the cable television companies. The Web that we know today could become the future distribution network for any quantity of dynamic media.

Telephony LISTSERV

Subscribing to a listserv or mailing list will undoubtedly give you insight and knowledge concerning audio and video on the Web.

The Videophone mailing list. This list addresses issues regarding videoconferencing.

> send e-mail to videophone-request@es.net. (archives for this list are available)

The VidConf mailing list addresses video and audio conferencing technology.

> send email to majordomo@pulver.com
> in the message body "subscribe vidconf"

CU-SeeMe Listservs include:

Cornell University's CU-SeeMe Announcement List
> send e-mail to listserv@cornell.edu
> "subscribe CU-SeeMe-Announce-L firstname lastname"

CU-SeeMe Discussion List (cu-seeme-l@cornell.edu)

CU-SeeMe Events List
> e-mail to list-admin@www.indstate.edu that says
> "subscribe CUSM-Events firstname lastname"

CU-SeeMe LISTSERV

Recently I received a call from a friend and long-time art collaborator, Bob Rizzo, who directs CONVERGENCE, (*http://www.ids.net/ ~festival/converge.htm*), an annual summer long International celebration of the arts.

Bob directs CONVERGENCE as part of his position with the Providence Parks Department in Providence, RI. He had heard various things about low-end video on the Internet and wondered whether it was possible for us to webcast the festival to an inter-

FIGURE 16 CU-SeeMe Netcast of "The Fireman's Fountain" at the
CONVERGENCE IX Festival

national audience. The artwork he was most interested in Webcast-
ing was "The Fireman's Fountain," a time-sensitive water sculpture
designed by Hardu Keck, artist and Provost at the Rhode Island School
of Design. Excited by the possibilities of working with CUSee-Me in a
large-scale event, I agreed to help and contacted White Pine Software
to determine the availability of a public event "reflector" for the target
date. A reflector is an Internet site configured with the server version
of CUSee-Me. It is where the transmission is received and redirected
so that it can be publically accessed. With White Pine's assurance
their public reflector was available, we sat down to look at all of the
logistics.

Enhanced CU-SeeMe was chosen because it requires no digitiz-
ing. We actually played directly from a Hi8 VCR into the MX-1 digital
mixer and into the PowerMac 7500 A/V where Enhanced CU-SeeMe
accepts the video signal and sends it out onto the Internet.

First and foremost was access to a T1 line onto the Internet. T1
is a fast telephone line rated at 1544 Kbps. The University of Rhode
Island in Providence agreed to collaborate and granted us access to
their T1 line and computer lab containing the necessary A/V class
machine with Enhanced CU-SeeMe.

In thinking about the live aspect of the event, I was reminded that the Web is global; it is where our connections cross many geographic boundaries and timelines so what time the Webcast actually occurred really didn't matter. The time that we put it on the Internet in Providence, RI wasn't the same as it was in California or Great Britain or New Zealand; the Internet transcends time.

Videotaping the actual event wouldn't necessarily require very specific equipment, but I had in mind what I thought would deliver the best results. The video configuration we decided on included shooting with Hi8, playing back on two Hi8 VCRs through a Videonics MX-1 digital video mixer.

The day arrived and mission was accomplished, pretty much as planned including the viewers from South Africa and other parts of the world.

JAVA

Java is a platform-independent programming language based on C++ created by Sun Microsystems (*http://java.sun.com*) that allows the making of stand-alone mini applications, referred to as "applets" optimized to run internally on intranets or the Internet. Netscape, Microsoft, Apple and a host of other large computer companies have begun integrating Java into their operating systems. Java support can also exist in a Web browser, as it does in Netscape Navigator 2.0+. Java applets allow cross-platform programmability and can be embedded right into HTML pages.

As exciting and accessible as these developments have been made out to be, they require a familiarity with programming. There are a significant number of Java applets active on the Web already. Download a Java compliant browser and visit Gamelan: Earthweb's Java Directory (*http://www.gamelan.com*), and there you will find examples of the new functionality the Web is gaining.

Java promises to enhance our online experiences with live customization and information updating. Each will contribute to the development of more dynamic documents. For a preview of where art and Java technology come together, visit Art Technology Group's Dynamo Main Page, (*http://www.atg-dynamo.com/dynamo/main*), where you will experience their Java-enhanced server.

ATG's Dynamo was implemented extensively in the Media Lab's "A Day in the Life of Cyberspace" (*http://www.1010.org*). On October 10, 1995 this Massachusetts Institute of Technology program celebrated its 10th anniversary in a unique way. For ten days leading up to "1010" millions of people around the world joined in contributing to "the first global portrait of life in the digital age." Logging on via the

010100110000101 tive participant

1001001 als

01 ing

 roduce

 the world

1001

0010001111 hese products

October 10, 1995 was *A Day in the Life of Cyberspace.*

The MIT Media Lab celebrated its 10th anniversary on 10/10/95 with a gala symposium looking at the past, present, and future of digital media. As part of this, we invited millions of people around the world to join in the first global portrait of life in the digital age. We asked them to consider the impact of this revolution, and to describe in words, sounds and pictures, the ways digital media are affecting all of us as we work, play, learn, and live our lives.

FIGURE 17 Media Lab's "A Day in the Life of Cyberspace" Website.

Web 1010, visitors were requested to contribute stories, sounds, and images, which resulted in the generation of 43,000 automatic and customized Web pages on the fly. It was ATG's Dynamo that provided the assistance in building this extraordinarily dynamic Web site.

DESIGN FOR THE REST OF US

The Web is constantly in an evolutionary state. Every individual who uses it contributes to that evolution and daily growth. The developments we describe demonstrate future directions on the Web, however, they may have changed slightly when you read this.

QuicktimeVR

We have all heard about donning the headsets that project a landscape through which you "move." Electronic gloves allow you to "handle" objects that don't really exist, all illustrations that describe Virtual Reality. The headsets were then resized down to goggles and the gloves became thin as skin. Now, none of this is necessary to navigate and experience objects and scenes from far away or invented places.

Navigating the halls of a museum or any environment takes place with the glide of the computer's mouse. Click on a key and you've zoomed in for a closer look at an object; click again and

you've zoomed out. Exploring a spatial territory is entirely possible from any desktop computer or even while on the web. QuickTime VR (*http://qtvr.quicktime.apple.com*) is an extension of Apple Computer's digital multimedia architecture called QuickTime. Quite-TimeVR is a cross platform architecture that allows you to actually experience and navigate though a 360 degree environment.

Shockwave

Shockwave is another descendant in Macromedia's long lineage of multimedia tools. Director, the program Shockwave relies on to develop the multimedia file, originated as an animation program. Today, animation is still one of Director's drawing cards, but it is not the major reason developers favor it. Director easily imports numerous file formats, which include digital video and audio. Lingo, its integrated Hypertalk language, enables users to quickly and easily script fully interactive applications. Director delivers on the promise Hypercard missed; it empowers not just programmers but anyone motivated enough to learn the program to develop fully interactive and stand-alone applications. According to Macromedia, more than 40% of all CD-ROM titles are developed with Director and now, in the form of Shockwave, some of that capability is moving to the Web (*http://www.macromedia.com*).

Shockwave is actually a suite of products that includes: Director, Afterburner and the Shockwave plug-in, which is compatible with the browsers Netscape Navigator and Microsoft's Internet Explorer. Once the Shockwave plug-in is installed, the process is entirely transparent to the user. Afterburner is a compression technology that enables the user to post-compress Director files with a simple "drag and drop" interface. Once compressed, the file is referred to just as any other file in an HTML tag. When the user encounters a Web site with "shocked" files, the browser displays the movies. Movies can include motion, sound and just as with any Director file, full interactivity.

With literally hundreds of thousands of Director users, many of whom are artists and designers, developing for the Web, Shockwave holds tremendous promise. It provides a vehicle for creating exciting and engaging content without the complications of writing complex code and guzzling up heaps of bandwidth.

GIF

While there are other file formats graphical browsers are capable of decoding, GIF and JPEG remain largely the two graphic file formats you will encounter on the Web.

GIF (Graphics Interchange Format) is a lossless standard that works with a palette of 2 to 256 shades of gray or colors. GIF is based on LZW compression (Lempel-Ziv-Welch algorithm) which reduces data without sacrificing quality.

There are a number of programs on all platforms that enable you to work with GIFs. GIF is not typically suited for photographic images and unlike JPEG, it does not allow the user to specify the levels of compression. There is, however, an excellent plug-in for Adobe Photoshop called PhotoGIF (*http://www.aris.com/boxtop/PhotoGIF*) that greatly enhances working with GIF, giving you more latitude with palettes and excellent compression.

Keep in mind that the average user is cruising the Web with a 14.4k modem, so the problem that faces every Web designer is. How do you keep the graphic file size small enough to not cause long delays in loading? Delays impede the dynamics of hypertext and chase those with slower connections away. Good design doesn't require bloated weighty graphics. Typically, elegant design emanates from simplicity. As you begin to design a Homepage, keep size in mind. When the user clicks, they are not anticipating a long wait; instead, they anticipate a quick reaction.

For examples of elegant Web sites take a look at Voyager's site (*http://www.voyagerco.com*). I also found, Elizabeth Roxby's Design In Motion an excellent example in this regard (*http://WWW.itp.tsoa.nyu.edu/~review/current/focus/Roxby1.intro.html*). Not only is it nice graphic design and good reading, but the way the hypertext carries it is distinctive. Design In Motion is a selection from the equally well designed NYU-ITP graduate student online magazine, "Review" (*http://WWW.itp.tsoa.nyu.edu/~review*).

JPEG (Joint Photographics Experts Group)

JPEG is a standard for a lossy compression that is applicable with continuous tone still images. In referring to compression earlier we mentioned that the user can determine how much of the image he or she will allow to degrade. Much of this also depends on how small a file size is required for your use. Is it intranet or Internet? On the Web, the smaller the graphic file size the better.

JPEG was specifically developed for continuous tone files that can be made up of 256 shades of gray, 8 bit (or a palette of 256 colors), 16 bit (or 34,000 colors), or 24 bit (or 16.8 million colors). Lossy compression simply means that once JPEG is applied there will be a loss of quality. In essence, each compression algorithm has its own

FIGURE 18 Voyager's utilitarian approach offers a clean look, making navigating their Website a snap.

way of choosing which information it can throw out to save space and still retain particular characteristics of the image.

MPEG (Motion Picture Experts Group)

MPEG is an ISO standard for dealing with motion video and audio storage on digital devices such as CD-ROM or hard disks. There are now four specific MPEG standards:

MPEG-I is relatively low resolution of about 352 by 240 pixels at 30 fps (US), which is optimized for CD-ROM storage applications with encoded bitrates (bit rates) of 1.5 Mbit/sec. It does retain high-quality CD audio characteristics.

MPEG-II is optimized for high quality video such as television broadcasting. It permits both interlaced and non-interlaced scanning schemes and will read MPEG-I data.

MPEG-III was designed with High Definition TV (HDTV) in mind. Its encoding was capable of bitrates of 20 and 40 Mbit/sec. HDTV now fits into MPEG-II's guidelines.

MPEG-IV. This initiative is still in the works with a draft specification due in 1997 and a sanction of the standard in 1998. While planned for very low bitrate coding (up to 64 kbit/s), it requires good quality for devices such as videophones over analog telephone lines. To achieve this higher compression MPEG-IV might demand new coding techniques be developed.

Anticipated uses other than videophones for this compression includes: interactive mobile multimedia communications, multimedia electronic mail, remote sensing, electronic newspapers, interactive multimedia databases, games and interactive computer imagery.

Animated GIF

An excellent example of the power of the Internet is the growth in popularity of animated GIFs. Dating back to 1987, the technical specifications for GIF supported the inclusion of more than one image per file, however, this capability was never implemented into an application. In 1989 in the next revision of the 89a GIF standard added a timing element. Just as animation has timing, the multiple frames could have a specific duration set for the playback of each frame. Once again there was no program that implemented these features.

As the Web evolved and GIFs became popular, Royal Frazier became interested in multiple-file GIFs through an introduction to Alchemy Mindworks' program, GIF Construction Set. In experimenting with these files, he discovered Netscape's Browser displayed the multiple images or streaming files. According to Frazier's own description on his Website, (*http://member.aol.com/royalef/royal.htm*), all of this came together primarily because of one other person's efforts: Heiner Wolf of Germany, who actively requested complete compliance with the 89a specification for all browsers at the World Wide Web conferences. Netscape was the first to comply. Frazier's publication of Frazier's discovery through an Internet newsgroup and his documentation of the process and necessary tools on his website, have resulted in a proliferation of GIF animation on the Web.

Everything you need to know about 89a GIF animation is on Royal's website, which includes a gallery of links to GIF animations at work. No particular plug-ins are required to display GIF animations on the Web. This is truly multimedia available to everyone.

THE TOOLS: WEB PAGE MAKING

HTML Editors

When you get around to creating a homepage there are many tools available to get you started. If you are not prepared to purchase one of the What You See Is What You Get (WYSIWYG) HTML layout tools that we list, the place to start is with an automated page maker that

lives on the Web (*http://www.wizard.com/~fifi/pagemake.html*).
Starting this way is easy, since all you do is answer the questions by
keying into the appropriate text fields. When you are finished, sim-
ply click "make my page" and your page is created automatically
with the correct HTML coding. What is special about this generator,
by Stephanie Arnold, is that it provides more than one way to input
text, and it gives you graphic images to chose from to dress up your
page as well. It creates a very professional-looking page. If all you
need is to get text on the page, then check out Greg Ritter's Auto-
matic Home Page Generator: (*http://ugweb.cs.ualberta.ca/
~ritter/cgi-bin/hpg.html*).

Now that you know the difference between an <a> and
and the meaning of <HEAD>, HTML editors or semi-WYSIWYG
editors are well worth looking at. They are often free or available for
a small shareware fee. There is an ample supply to chose from on
the Internet, and some of them really get the job done.

PageSpinner is a very solid semi-WYSIWYG editor for the Mac-
intosh (*http://www.algonet.se/~optima/pagespinner.html*) This share-
ware is about the closest you will find to a WYSIWYG program. It
supports both HTML 2.0, parts of HTML 3.0 plus most Netscape
extensions with limited JavaScript..

Arachnid HTML is a modest editor optimized to work with
Netscape; it is available for both Macintosh and Windows.

Support the shareware system. Like PageSpinner and Arachnid,
you can find first-rate programs on the Internet. All of the shareware
programs we've mentioned are well worth their shareware fees.

After working with HTML for a while you may want to know
where to access other good HTML tools. You will find a well-
organized cache of links including: style guides, text editors, con-
version tools, graphic sites and even Java links at Chris Steele's site
(*http://www.interlog.com/~csteele/newbie4.html*).

WYSIWYG –The New Generation Pagemaker

PageMill
Just as Adobe was instrumental in the evolution of Desktop Publish-
ing, it is establishing itself in Web development with the first cross-
platform WYSIWYG software application, PageMill
(*http://www.adobe.com*) and Adobe Acrobat.

Acrobat is a suite of electronic publishing products that operates
cross-platform in a PostScript-based file format called, Portable Doc-
ument Format (PDF). PDF readers or viewers, are available free at
numerous sites on the Web and enable the browsers to seamlessly

FIGURE 19 With HTML Editors such as Adobe PageMill, pages appear on the desktop just as they do in a browser.

read graphically rich documents in a resolution independent format. Documents encapsulated in the PDF format are small and are dynamic themselves because they can contain URL links and are print ready.

Anyone familiar with a Desktop layout program will feel comfortable right from the start with PageMill. A WYSIWYG program is different from a semi-WYSIWYG because you are masked from the HTML; pages appear exactly as they are displayed in a browser. Text is keyed in and stylized as desired and JPEG and GIF images are positioned where you want them. All links and graphics are put in place through a simple drag and drop interface.

Adobe also offers SiteMill, a Web server software that allows users to easily manage a Website with features like automated checking of all links.

Hotmetal Pro

SoftQuad Inc.'s HoTMetaL PRO was an early entry and it is a favorite of many web authors. It is available for MS-Windows 95/NT/3.xx, Macintosh and Unix (*http://www.sq.com/products/hotmetal/hmp-org.htm*).

Claris HomePage

Claris has introduced HomePage (*http://www.claris.com*), their Macintosh and Windows WYSIWYG solution, which enables many of the advanced features you would expect in a package of this type: JavaScript, image mapping, tables and framemaking.

Netscape Navigator Gold 3.0

Not to be outdone in an area it dominates, Netscape's Navigator Gold 3.0 integrates complete WYSIWYG editing into the browser and provides extensive access to resources on their web site including live templates, graphics, techniques and tips (*http://home.netscape.com/comprod/mirror/index.html*).

Remember that these programs can assist you in putting together your web pages but "content" remains the most important requirement for making any website interesting and appealing.

Web Links: An Alphabetical Listing

<div style="text-align: right;">**7**</div>

A

ABC–American Broadcasting Company/Capcities (see television networks)

American Broadcasting Company

http://www.abctelevision.com
news, programming, monthly events, some shows highlighted on home page
 http://www.realaudio.com/contenp/abc.html
ABC news reports in audio format

Academy of Television Arts & Sciences

http://www.emmys.org/
The home page includes contact information and links to activities and events, Emmy awards, educational programs, etc.

The Actors Web

http://www.starone.com/actorsweb/
Interactive directory of professional actors. Search by type or actor's name.

ADDRESSES AND DIRECTORIES

The Electronic Activitist
http://www.bershire.net/~iafs/activist/
E-mail addresses for government and other public figures

Four-11 White Pages
http://www.four11.com/
White pages for the Internet.

NYnet E-Mail Address Directory
http://www.soho.ios.com/~nynet/email.html
Hard to find e-mail addresses of celebrities and political figures.

Switchboard
http://www.switchboard.com/
Residential telephone numbers and addresses for almost everybody in the U.S.

Alliance for Competitive Communications
http://bell.com/
"A coalition of the seven regional Bell operating companies." The home page includes information about the group and its mission, and links to information about telecommunications policies, legislation, and conferences.

American Communication Association
http://www.uark.edu/depts/comminfo/www/ACA.html
Very useful site provided by the association for professionals, professors, and students in the field of communications. Includes information about the association, excellent links to communication law and policy, communication studies, and on-line references. This site also has a complete link to bookshops and publishers.

American Communication Association Electronic Reference Desk
http://www.uark.edu/depts/comminfo/www/refdesk.html
Links to communication associations, about research grants and fellowship, career opportunites, travel opportunites and more.

American National Standards Institute
http://www.ansi.org/

American National Standards Institute
ANSI news and events, links to standards information, education and training

ANIMATION/COMPUTER GRAPHICS AND RELATED SITES

Academy for the Advancement of Science and Technology
http://www.bergen.gov/AAST/
Many cool examples of great student web projects. Be sure to check out some of the Project Quickview pages.

Animation on the Net
http://www.emap.com/animation/links.htm
Links to hundreds of animation sites organized by categories.

Cornell Theory Center—Visualization
http://www.tc.cornell.edu/Visualization
Software and hardware information as well as impressive student animation works.

Evolution of Computer Animation
http://www.bergen.gov/AAST/ComputerAnimation/CompAn_Evolution.html
Great site displays timeline, history and methods of animation. Links to other useful sites regarding computer animation.

Hollywood
http://www.geocities.com/Hollywood/
*Home pages of artists who display recent work from Star Trek, Pink Floyd, and personal information.
 http://www.geocities.com/Hollywood/1645/images.html
 *The Psycho home page. Be sure to check out the shower sequence!

Ladislas Starewicz
http://www.itserve.com/~tfitz/stare1.html
Page dedicated to one of the founders of 3-D stop motion animation. Links to some of his work.

Moving Media
http://www.MovingMedia.com
Home page for graphics company. Great examples of web animation.

Vintage Ink and Paint Homepage
http://www.vintageip.com/
Lots of great information about animation art including a glossary of terms.

Animated GIFs
Home of URL Manager, URL Manager Pro and Smart Dubbing with Java Sound
http://www.xs4all.nl/~polder/Gaal.html
URL Manager Pro was used extensively in putting this book together. Smart Dubbing is a very clever way toconvert QuickTime Movies to animated GIF. A Macintosh only product.

Royal Frasier details on 89a GIF animation
http://member.aol.com/royalef/royal.htm
The first home of 89a Gif Animation.

Apple Computer
http://www.apple.com/
A smattering of Apple Computer's many Homes can be found at:
http://always.apple.com/
Always Apple is an interesting site devoted to interaction
between Apple employees and its customers.
http://qtvr.quicktime.apple.com/
Home of QuicktimeVR, the 360 degree perspective in digital
moviemaking.

Arizona Sight and Sound Video Production, Inc.
http://www.tucson.com:80/dating/video.html
The corporate home page includes a list of services offered, con-
tacts for pricing and ordering, and links to video and animation
sample clips.

ART, ART DESIGN, and ART RELATED SITES
Art History & Multimedia
http://ascilite95.unimelb.edu.au/SMTU/ASCILITE95/abstracts/Mar-shall.html
CyberVato and the Ethno-Technographic Survey
http://riceinfo.rice.edu/projects/CyberVato/
Collaboration performance/installation at Rice University Gallery,
and MECA. These internationally known performance artists:
Guillermo Gómez-Peña, James Luna and Roberto Sifuentes doing
their stuff. Originated as a live CUSee-Me performance work.
Dana Atchley's D3TV
http://www.nextexit.com/index.shtml
Atchley is a longtime video artist of acclaim who has been referred
to as the shaman of the digital set
FineArt Forum Online
http://www.msstate.edu/Fineart_Online/home.html
Art & technology netnews
Excellent collection of Artists and Exhibits online
http://www.ncsa.uiuc.edu/EVL/docs/html/homePage.html
Home of Jeff Morlan.
http://www.sos.net/home/jef/
Beautiful spatial sensibilties created by this artist.

IMAGESITE

http://www.imagesite.com/
An Index for the Visual Arts

Jodi.Org

http://www.jodi.org
A tremendous mix of art and technology. Where does this assault come from? Where is it going? It wants to be experienced today, maybe.

Massachusetts College of Art

http://www.massart.mass.edu/
America's oldest and only public art college.

Online Art Dinner

http://www.uiah.fi/~lauri/online/
Online Art Dinner is modern performance which includes elements from several forms of art; classical music, acting, poetry, painting, photography and theatre.

Reese design studio

http://www.imagine-net.com/creese/
Example of Nice Design on the web

sf/TeleCircus

http://www.well.com/user/tcircus/
This site gives an inside look at the "artso-digital" world of San Francisco. Includes: Flathead, Cobra Lounge, Burning Man, Cyberlab 7, JOE'S DIGITAL DINER and The Residents

SOLART GLOBAL NETWORK HOME PAGE

http://www-mitpress.mit.edu/Leonardo/solart/solartHome.html

Virtus Corp: 3-D gallery

http://www.virtus.com/gallery.html
Home of the Voyager VRML browser

Viewpoint

http://www.viewpoint.com/
Large collection of 3D Models.

A Digital Studio Devoted to Education Content

http://www.CyberSchool2000.com.
Cyber School's mission is to deliver high quality education content via the Internet. Hosted by Adam Engst, author of the best seller, *The Internet Starter Kit/* (Hayden Books), and columnist for *Mac Week* magazine.

Association of America's Public Television Stations

http://universe.digex.net:80/~apts/
Links include information about the APTS, political and grassroots activities of public broadcasters, press releases, positions papers, publications, related sites, etc.

AUDIO RELATED LINKS
Audio Engineering Society
http://www.aes.org/
The home page includes information about and links to local AES
Sections, the Journal of the AES, AES publications, standards, edu-
cation, other audio information, and other audio web sites.
Mission Recording and Audio Online
http://www.missionrec.com/adbspec.html
Society of Professional Audio Recording Services
http://www.webcom.com/spars/welcome.html

INTERNET AUDIO APPLICATIONS
C/NET
http://www.cnet.com

WebTalk
http://arachnid.qdeck.com/qdeck/products/webtalk

NYU Interactive Telecommunications Program
http://WWW.itp.tsoa.nyu.edu

Radio Insomnia
http://www.mackerel.com/folk/personals/insomnia/
homeinsomnia.html
http://www.mackerel.com/
Great use of animated graphics and sound. Produced by
Cindy Dabis, Art Director and Project Director for the
renowned Toronto based new media company, Mackerel
Interactive Multimedia

Australian Broadcasting Corporation–ABC
http://www.abc.net.au/
Home page includes links to information about the company, TV,
radio, news headlines, and featured sites.

AUTHORS
philip palombo, HomePage
http://www1.ussa1.com/~palombo

B

British Broadcasting Corporation–BBC
http://www.bbcnc.org.uk
Radio, tv, education, world service, internet services of the BBC

Benton Foundation (See also Telecommunications Act)

http://www.cdinet.com/Benton/Home/
Non profit foundation promoting information and dialog on issues related to strategic communications, children, and communications policymaking. Home page provides information about the orgainization, on-going conferences, projects, calls for papers, research, etc. Excellent links to other non-profit and telecommunications resources on the Web.

Benton Foundation's Communications Policy Project
http://www.cdinet.com/Benton/
A project promoting the discussion about the National Information Infrastructure.

Debate on the Future of Television
http://www.cdinet.com/Benton/TV/debate.html
Excellent series of papers and links looking at economic and policy issues of HDTV.

Bibliography on scholarly electronic forums

http://www.oise.on.ca/~arojo/bibliog.html
A list of scholarly work on topics related to computers, the internet, and communication. Some links to authors provided.

Broadcast Education Association

http://www.usu.edu/~bea/
A professional association for electronic media professionals, professors, and researchers. The home page includes links to BEA news and information, publications, scholarships, memberships, conventions, etc.

Broadcast Technology

http://biomed.nus.sg/broadcast/menu.html
A page of information produced by the Television Corporation of Singapore. Includes links to information about broadcast standards, new technologies, glossary of terms, and to home pages of research and commercial organizations working in broadcast technology.

C

CABLE TELEVISION ASSOCIATIONS
California Cable Television Association
http://199.35.198.70/chan40/chan40.htm
Information about the background, activities and members of the CCTA

Ohio Cable Telecommunications Association
http://www.tcssoftware.com/octa/
Home page includes links to a glossary of cable terms, upcoming events, membership lists, legislative and regulatory info, public affairs, and a list of industry web sites.

Pennsylvania Cable & Telecommunications Association
http://www.pcta.com/pctahome.html
a lobbying group for state and federal legislatures. Includes links to transcripts of testimony by the association president, texts of regulations, meetings and events, cable in the classroom, the association magazine, etc.

Society of Cable Telecommunications Engineers
http://www.cable-online.com/sctehome.htm
Includes information of training opportunities, industry events, and standards development activities

CABLE RADIO INFORMATION
Cable Radio Network
http://www.calypso.com/radio/
links to advertising, demographics, format, coverage, time & station, areas of distribution

CABLE TELEVISION INFORMATION
Broadband Bob's CATV Cyberlab
http://www.tezcat.com/~chicago/catv1.shtml
Links to topics like: cable modem resource guide, the cable classroom, interactive television, fiber optics, operators/MSOs, publications,

FCC Cable Services Bureau
http://www.fcc.gov/csb.html
Provides links to news releases, public notices, orders, notices, informational reports of the Commission.

Millennium
http://wir.com/millennium/
A "full service communications company" specializing in "cable television, alternate access telecommunication, and distance learning"

@Home Network
http://www.home.net/
Uses cable infrastructure to provide broad band data to PCs allowing faster connections to the internet. Good for video, audio, multimedia in the net

http://www.paytv.com/
If you sift through a couple of pages of menus and submenus you can get to just about any page having to do with cable television.

a research and development group whose members are cable system operators

http://www.cable-online.com/
Industry news. Links to text based news stories, telecommunications, programming and local systems, Cable Online participants, industry services (good set of pages)

http://www.cableconnect.com/
Provides web links to cable information, i.e.. industry, newsfeeds, systems, channels, news groups

CABLE TELEVISION SYSTEMS AND MULTIPLE SYSTEM OWNERS

CableVision Corporation
http://moon.cablevision.com/
corporate home page of large MSO includes company news and information, links to local system operators, and to a live video feed

Continental Cable
http://www.continental.com/
Links to corporate information, local operator listings, searchable tv schedules, educational programming, company press releases, "customer handbook" glossary and explanations of cable television, (I liked this one, the interactive tv schedule really worked–though they aren't in our area–and the handbook had interesting info)

Cox Cable Systems
http://www.cox.com/
MSO corporate home page, includes company info: current, historical, financial and technological

Rogers Cable
http://www.rogers.com/Cable/
MSO providing traditional cable and high speed internet connections. Corporate home page has links to company news and info, local operator lists, employment opportunities, internet connection info and FAQs.

TeleCommunications Inc.
http://www.tcinc.com/
TCI corporate home page. Includes links to TCI services: high speed internet connection, educational programming, news programming, advanced information technology

Time-Warner Cable
*http://pathfinder.com/@@RiSLTDBupgEAQE*O/Corp/divisions/cablehome.html*
Time Warner Cable home page included links to news and info about TWC as well as links to other Warner pages (i.e.. HBO, Warner music, Time Inc., and Warner Brothers)

Canadian Broadcasting Corporation—CBC

http://www.cbc.ca
links to information about English and French television and radio broadcasts, news, what's new about CBC, talk to CBC

CBS–Columbia Broadcasting System/Westinghouse Corp (see television and cable networks)

http://www.cbsradio.com
links to syndicated radio shows, affiliate list buried on sub pages

Center for Democracy and Technology

http://www.cdt.org/
Homepage for the CDT, a non-profit public interest organization
devoted to advocating public policies that enhance civil liberties.
Good links related to net censorship, privacy, cryptography issues,
digital telephones and other hot constitutional issues.

CHILDREN AND MEDIA LINKS

Ad hoc Children's Television Act Web Page
http://www.cme.org/cme/kidstv.html

Advertising—Advertising to Kids
http://www.kqed.org/fromKQED/Cell/chen/adv.html

America's Lost Children Television Network, Inc.
http://alctv.com/

Children and Television
http://www.earthlink.net/~cml/children.html

Children's Issues
http://www.fcc.gov/children.html (

Children Now - Children's Television Act
http://www.dnai.com/~children/action/cta.html

Couch Potato Chronicles 2.2, 2/94: Children's television
http://www.boston.com/wgbh/pages/audienceresearch/cpc/cpc.2.2.html

KFOR 4 KIDS KFOR-TV
http://www.keytech.com/kforkids/

Music, Television and Video Games and Their Effect on Children
http://www.cwrl.utexas.edu/~tonya/VideoGames/3.html (

ORGANIZATIONS—AAP
http://edie.cprost.sfu.ca/gcnet/ISS4-21c.html

SMART PARENT'S GUIDE TO KIDS' TV
http://kqed.org/fromKQED/Cell/chen/miltonmenu.html
Survey on Kids TV Debate
http://www.cep.org/survey.html
TelecomReg: Re: Action Alert for Quality kids' TV
http://www.wiltel.com/telecomr/archive/0382.html

Chronicle of Higher Education

http://chronicle.merit.edu/

CNN (see television and cable networks)

http://www.cnn.com/
The CNN home page includes headlines of the day's top news, and links to the full stories, as well as links to specialty stories grouped by national and world news, showbiz, weather, food & health, sports, technology, politics, and style.

College Media Advisers, Inc.

http://bart.spub.ksu.edu/~cma/
A professional association of advisors to student media organizations. The home page includes links to information about the association, committees, workshops, conventions, newsletters, awards, events, publications.

Claris HomePage

http://www.claris.com

Comedy Central (see television and cable networks)

http://www.comcentral.com/

Comunicacion Organizacional

http://www.cem.itesm.mx/dacs/editor/443316/corporativa.html
A Mexican organization of corporate communicators, home page in English and Spanish. Provides links to pages with information about cross cultural communication, corporate identity, the International Association of Business Communicators, etc.

Creativity Cafe Home Page

http://skywebs.com/cre8/ccafe/
The Creative Cafe focuses on creative expression and interactive entertainment. Home page includes basic information and links to resources, chat rooms, guest book.

Critical Approaches to Culture, Communications and Hypermedia

http://www.facl.mcgill.ca/burnett/englishhome2.html
Home page of a communications faculty member of McGill University. Includes specific links to classes he teaches, as well as general links to communications, hypermedia, and digital imagery.

C-Span(see television and cable networks)

http://www.c-span.org/
The home page offers an image and blurb about what's currently airing and links to live real audio of House and Senate action. The page also includes links to weekly shows, features, digital images, schedules, education, The Washington Journal, Congress Today, etc.

Cyber Film School (see also film)

http://www.cyberfilmschool.com/
Can't view without Netscape 2.0

CyberOne

http://www.cyberone.com/
Innovative web development and applications. Animation of Web page is worth the look.

Cartoon Network (see television and cable networks)

http://www.filmzone.com/SpaceGhost/cartoonnet.html

Center for Documentary Studies

http://www.duke.edu/doubletake/cds/
Home page includes links to information about the center and its activities, projects and grants, publications, courses, DoubleTake magazine, and a gallery of documentary work.

Center for Foreign Journalists

http://solar.rtd.utk.edu/~ccsi/csusa/media/forjourn.html
The Center provides training for journalists from around the world. The home page provides information about the Center's background, programs, publications, etc.

Central States Communication Association

http://www.cs.bgsu.edu/~jburns/csca.html
Home page provides information about the organization, its history and activities, and links to women in the media related gopher sites.

Cleveland State University Law Library

http://www..law.csuohio.edu/lawlibrary/index.html
Home page to CSU's Law Library. This site provides a link to general
Web resources like the WWW Virtual Library and the Internet Public
Library. *See HOT ITEMS link:

 http://www.law.csuohio.edu/lawlibrary/hot.html
 Excellent links to law, government, and political information

CU-SeeMe Software Sites (see also teleconferencing)

Cornell Unviersity
http://cu-seeme.cornell.edu

White Pine Software
http://www.cu-seeme.com

D

Dejanews Research Service

http://www.dejanews.com/
Search engine for newsgroups.

The Digital City Foundation

http://www.dds.nl/dds/info/english/index.html
A test bed for the electronic highway (April, 1995)

Disney Company Related Sites
(see ABC/Capcities and television networks)

http://www.disney.com/DisneyRecords/?GL=H
Links to new releases, soundtracks, song albums, read alongs, sing
alongs, collections, downloads, history and store list, as well as fea-
tures releases.

 http://www.disney.com/index.html?referer=
 ^DisneyPictures^&GL=H
 Links to information about movies, books, shopping, travel
 à la Disney
 http://www.disney.com/DisneyPictures/?GL=H
 Features information about movies, contains photos and
 information.
 http://www.disney.com/investors/index.html
 Home page of the Walt Disney Company. Mission statement,
 financial information and frequently asked questions are
 answered.

Doceo Publishing, Inc.
http://www.doceo.com/
Digital video production company. Home page includes links to information about products, services, messages from the CEO.

E

Early Motion Pictures (see also films)
http://rs6.loc.gov/ammem/papr/mpixhome.html
The early years of film, 1897-1916. Includes links to downloading short films, and to information about restrictions, technical notes, early films, America at the turn of the century, etc.

EarthLink's Hollywood
http://www.earthlink.net/hollywood/
Pages of resources and information about the entertainment industry. Home page includes links to studios, networks, movies, TV shows, actors, actresses, directors, products, reviews, production related sites, guilds and organizations, etc.

Ecology Channel
http://www.ecology.com/
An Internet/ Multimedia program service. Earth Day special information, check on endangered species, get tips on how to tips and information about the Ecology channel at the same time. Links to environmentally conscious publications, etc.

EDUCATION AND THE INTERNET
Primenet
http://www.primenet.com/links/education.html
Page links some of the best examples of using the Internet for educational purposes. Links to educational resources. *Especially notable is the Interactive Frog Dissection link.

Students for Exploration and Development of Space
http://www.seds.org/
SEDS has a great archieve of space images, links to NASA, Space Station Alpha, and current space missions.

Electronic Frontier Foundation
http://www.eff.org/index.html
Homepage of the non-profit civil liberties organization that helped spearhead the effort against censorship on the Web. Many excellent links to background information related to freedom of expression

Emerging Media

http://www.chiatday.com/cd.www/explor/emerg/emerg.html
A small collection of papers about new media technologies collected by the Idea Factory.

ESPN (see television and cable networks)

http://espnet.sportszone.com/
Home page inlcudes sports headlines with links to the full stories, scores and statistics of in season sports,

Ethnicity, Racism and the Media

http://www.brad.ac.uk/bradinfo/research/eram/eram.html
A project by the University of Bradford (UK) to promote the discussion, dissemination, and research collaboration of issues relating to racism, ethnicity, and the media.

F

Fairness & Accuracy in Reporting

http://www.fair.org/fair/
A national media watch group, the home page includes information about the organization, and links to various FAIR publications, special reports, activities, and related web sites.

FASHION
7thOnline
http://www.fashion.net/7thOnLine/

FEDERAL GOVERNMENT LINKS
FedWorld Information Net
http://www.fedworld.gov/
Provides FTP and Telnet links to federal information computers. Other links to jobs, recent government publications, US Govern. Information Servers, etc.

Federal Communications Commission

http://www.fcc.gov/
Home page includes dozens of links to information about the FCC in general, commissioners, bureaus and offices, hot topics, text versions of proceedings, acts, speeches, consumer info, etc.

Federal Government Resources
http://neon.nlc.state.ne.us/test/nedevnet/fedgovt.html
Includes links to a page of all federal government web sites, as well

as specific links to agencies such as the FCC, HUD, etc. Great starting place when you need to look up a government link.

Information Infrastructure Task Force
http://www.iitf.doc.gov/
NII links to servers and information

FBI Home Page
http://www.fbi.gov/
Home page of the Bureau. Link to America's 'Ten Most Wanted"
Hotlines and info on current Bureau investigations. Provides good background for cub reporters.

Federal Communications Bar Association
http://www.fcba.org/
Professional association of attorneys and professionals involved in the development, interpretation, and regulation of communications law and policy. Links to the Federal Communications Law Journal and other useful places.

Fox–Fox Television Network/ News Corp (see television and cable networks)
http://foxworld.com/entertainment/

FILM RESOURCES AND LINKS
Film and Television Studies
http://english-www.hss.cmu.edu/filmtv/
An alphabetical list of authors and links to the works they've written in the field of film and television.

Film and Video Resources
http://http2.sils.umich.edu/Public/fvl/film.html
A list of internet resources pertaining to film and video complied at the University of Michigan. Some sample links include: Brown Film Society, Instructional Media Center's Gopher, and Science Fiction Movie Reviews.

Early Motion Pictures
http://rs6.loc.gov/ammem/papr/mpixhome.html

FILM/MEDIA STUDIES
Alfred Hitchcock
http://nextdch.mty.itesm.mx/~plopezg/Kaplan/Hitchcock.html
Wonderful site to learn about the master storyteller, Alfred Hitchcock–the "Master of Suspense" and what Hitchcock mastered was not only the art of making films but also the task of taming his own raging imagination.

Film Festivals on the World Wide Web
http://www.laig.com/law/entlaw/filmfes.htm

**THE UFVA STUDENT FILM & VIDEO FESTIVAL
—Directory**
http://astro.temple.edu/~dkluft/directory.html

**THE UFVA STUDENT FILM & VIDEO FESTIVAL
—Festlinks**
http://astro.temple.edu/~dkluft/festlinks.html

FOREIGN LANGUAGES

FBIS Foreign Language Glossaries
http://www.fedworld.gov/fbis/
Want to know Portuguese terms for drugs? Need to find the correct
Swedish abbreviations for money? Here are links to world wide
glossaries of abbreviatons.

G

GAMES

E-On (Entertainment Online)
http://www.e-on.com/point4?pg=/index4.html
Rather interesting on-line games site and magazine. Colorful anima-
tions and graphics. Subscription required (free)

Geocities Homepage
http://www.geocities.com/
Links to various geocities sites.

Geocities Hollywood Homepage
http://www.geocities.com/cgi-bin/main/Hollywood/
Very imaginative site with links to locations, maps, studios,
animation, and picture gallery. This site is worth a visit.

H

Hearst Communication
http://www.hearstcorp.com/
Communication company with interest in emany aspects of the
communications industry. The home page has links to Hearst pages
on publishing, newspapers, new media & technology, broadcasting,
magazines, entertainment & syndication, company news and info,
monthly features.

High Definition Television Related Sites

Advanced Television Systems Committee
http://www.atsc.org/index.html
Advanced Television Systems Committee sets technical standards for ATV. Includes links to its members, information on standards, and relevant FCC pages.

ARPA HIGH-DEFINITION SYSTEMS PROGRAM
http://www.ti.com/corp/docs/pressrel/1994/419asc.html

DNP's High Definition GRAPHICS
http://www.dnp.co.jp/eng/dnp/fields/multimedia/hv.html

High Definition Television High Definition Television
http://www.bev.net/education/bhs/io/hdtv.html

HDTV: Higher Definition TeleVision
http://www.serve.com/lambhorn/hdtv.html

High Definition Systems in Japan
http://itri.loyola.edu/annrprt93_94/HDS.htm

High Definition: Whose Needs, Whose Standards?
http://www.nfb.ca/FMT/E/86/86116.html

High Definition Systems (Group J)
http://www.eaw.com/Pages/PROD/GrpJ/GrpJ.html

Project Summaries
http://www.igd.fhg.de/www/projects/wise/english/rd/3fw/RACE2/projects/1018.html

Sony High Definition Web Page
http://www.spe.sony.com/Pictures/Hidef/sphweb.htm

TelecomReg: high definition television
http://www.wiltel.com/telecomr/archive/0254.html

Home Box Office (see television and cable networks)
*http://pathfinder.com/@@RiSLTDBupgEAQE*O/Corp/divisions/hbohome.html*
HBO corporate information

Hughes Electronics
http://www.hcisat.com/indexl.html
Hughes communication company information, access to customer magazine, satellite services. *Neat page: satellite 101: teaches basics about how satellites work.

The Hollywood Reporter Web Site
http://www.hollywoodreporter.com/
Subscribe to the daily trade publication or check out Hollywood Hyperlink. Great resource to film/television related activities, people, etc.

Horizon Film and Graphics

http://izzy.net:80/~cory/

The home page is an unlabeled graphic image with six links embeded within leading to information about the company, its products, services, and the technology it uses.

HTML, VRML INFORMATION AND WEB DEVELOPMENT INFORMATION

Adobe Corporation's PageMill
http://www.adobe.com

Chris Steele's
http://www.interlog.com/~csteele/newbie4.html

Greg Ritter's Page maker
http://ugweb.cs.ualberta.ca/~ritter/cgi-bin/hpg.htm

Home of PageSpinner semi-WYSIWYG editor for the Macintosh
http://www.algonet.se/~optima/pagespinner.html

HoTMetaL PRO
http://www.sq.com/products/hotmetal/hmp-org.htm

Netscape's Navigator Gold 3.0
http://home.netscape.com/comprod/mirror/index.html

VRML
Moving Worlds VRML 2.0 Specification and Credits
http://vrml.sgi.com/moving-worlds/spec/credits.html

I

IASTAR Europe

http://www.iastar.org/

The International Association of Student Television and Radio stations. Includes information about the organization, lists of member universities, technical information, and current work.

Independent Television Service

http://www.actwin.com/ITVS/

An organization devoted to promoting and funding independent tv producers for shows to be broadcast of public television. The home page includes links to information about the organization, its activities and successes, programming, and related sites.

Information Technology and Society Discussion Group

http://www.wam.umd.edu/~weyker/its.html
The home page for a discussion group includes information about the group in general, meeting times, topics, and speakers, and links to essays on relevant topics.

Information Infrastructure Task Force

http://www.iitf.doc.gov/
This server provides links to a comprehensive set of documents related to the National Information Infrastructure (NII) initative. Links to other government and telecommunications related servers provides a comprehensive introduction to the NII.

Institute for Information Technology—Canada

http://www.iit.nrc.ca/
Home page includes links to each of the research groups and information about publications, collaborations, staff, patents, industry interactions.

Integrated Services Digital Networks (ISDN)
NYNEX
http://www.nynex.com/isdn/isdn.html

INTERACTIVE WEB SITES (see also multimedia, annimation, and film)
Abbe Don Interactive
http://www.abbedon.com/
Home of the well known interactive storyteller

6666-Under Corruption
http://www.ping.be/FFF/
An interactive art project.

Arc, The Interactive Media Festival
http://www.spark.com/
International in scope

Digital Planet
http://www.digiplanet.com/
A beautifully designed site and home of the original entertainment Web adventure, Madeleine's Mind.

FutureLessFuture
http://www.flf.org/FLF
A wonderful example of interactivity and what a cybergallery it is.The introductory essay by Donald Kuspit for the FuturelessFuture web art exhibition lives here

Also available with source material hyperlinks at:
http://plaza.interport.net/FLF/flf.text.html

HyperBole Online
http://www.hyperbole.com/
Acclaimed Interactive storytelling studio.

San Franciso Digital Media Center
http://www.well.com/user/sfdmc/sfdmc.html
This organization has been instrumental educating and presenting
New Media developments.

International Association of Business Communicators

http://www.iabc.com//homepage.htm
Home page contains link to information about the organization,
local chapters, services, conferences, publications, etc.

International Communications Industries Association

http://www.usa.net/icia/
Home page includes links to information about ICIA, sponsored
programs, publications, members with web pages, how to become a
member, events, dealer services, press releases, etc.

International Telecommunication Union

http://www.itu.ch/
An international organization coordinating global telecom networks
and services. The home page includes information about the organi-
zation and links to ITU highlights and current topics, telecom stan-
dardization, telecom development, and radion communication.

Internet Audio Software Applications (see Audio)

Roxby's Design In Motion

http://WWW.itp.tsoa.nyu.edu/~review/current/focus/Roxby1.intro.html
Referred to as example.

J

JAVA
Home of Java
http://java.sun.com
Sun Microsystems' Java Page
Gamelan: Earthweb's Java Directory
http://www.gamelan.com
Examples of Java Technology In Action

Dynamo Main

http://www.atg-dynamo.com/dynamo/main
Examples of dynamic server based page generation and JAVA.

Journalist's Toolbox

http://studentpress.journ.umn.edu/toolbox/journ.html
A long list of sites related to professional and student journalism.
Listed alphabetically and including such links as: American Amateur Press Association, Broadcast Education Association, College Press Network, National Association of Black Journalists, RP News.

Kuester Law

http://www.kuesterlaw.com/
A series of technology related law resources pages. Inlcudes general information, lists of technology lawyer, general law resources, case laws and statutes, etc.

LAW AND LEGAL LINKS

Cleveland State University Law Library
http://www..law.csuohio.edu/lawlibrary/index.html
Home page to CSU's Law Library. This site provides a link to general Web resources like the WWW Virtual Library and the Internet Public Library. *See HOT ITEMS link:
 http://www.law.csuohio.edu/lawlibrary/hot.html
 Excellent links to law, government, and political information

Federal Communications Bar Association
(see also Federal Links)
http://www.fcba.org/

Law Talk–The Constitution and Its Amendments
http://www.law.indiana.edu/law/amend.html
An audio based page that provides files on Constitutional issues related to freedom of speech, commercial speech, obscenity issues as well as other Constitutional Amendment issues.

George Lucas Educational Foundation

http://glef.org/
Links to the educational foundation's fact sheet, mission statement, past and current issues of the newsletter, and street and email addresses of contacts at the foundation.

University of Luton: Media Arts: Convergence

http://www.luton.ac.uk/Humanities/MediaArts/
Convergence/Convergence.html
A refereed academic journal for new media technologies. Web page includes principal aims, submission and subscription information, editorial board, and links to abstracts from the current issue.

M

MEDIA LAB

Home Page; MIT Media laboratory; MIT's MediaLab...
http://debussy.media.mit.edu/alternate-lab-homepage.html
MIT Media Lab
The Electric Postcard/Judith Donath/MIT Media Lab
http://persona.www.media.mit.edu/Postcards/
http://persona.www.media.mit.edu/Postcards/artNRack.html
Home of the first digital postcard.
A Day in the Life of Cyberspace

Fishwrap—Main page
http://fishwrap.mit.edu/
News of the future
http://www.1010.org

Media Lab: New and Noteworthy
http://www.media.mit.edu/MediaLab/Noteworthy.html

MEDIA LAW RELATED SITES

http://pages.nyu.edu/~schiffmn/
The starting point for the global law resource center, with links to media law, entertainment law, internet law, licensing, etc. Note, pages are under construction and there isn't much there yet.

http://www.medialinkvideonews.com
Provides daily satellite newsfeeds to journalists

MAGAZINES, ZINES, AND DIRECTORIES

CERN's Electronic Journals list
http://info.cern.ch/hypertext/DataSources/bySubject/
Electronic_Journals.html
Directory of electronic journals; e-journal web servers; list of links

Electronic Texts and Publishing (Library of Congress)
http://lcweb.loc.gov/global/etext/etext.html

Search the E-Zines Database
http://www.middlebury.edu/~otisg/zines.shtml
Search tools for finding magazines on the Web.

Guide to Magazines on the Web
http://www.io.org/~gigawat/mags.htm
Lists of links to magazines grouped by category: business, finance, journalism, business technology, computer sales, gaming, general computing, internet, Macintosh, PC/windows, other platforms, law journals, publishers, etc.

Communication Arts Magazine
http://www.commarts.com/
The Electronic Visualization Laboratory (EVL) of UIC advances research in computer graphics and interactive techniques through its unique interdisciplinary blend of technology and art.

Cyberia
http://magazine.cyberiacafe.net/issue-1.1/
An on-line magazine of news, features, humor, etc.

Hot Wired
http://www.hotwired.com/
*Excellent magazine with articles covering a wide spectrum of topics, but covers happening and trends on the Web. HotWired is free but requires subscription.

Inter@ctive Week
http://www.zdnet.com/intweek/
An excellent source

Leonardo Electronic Almanac Gallery.
http://www-mitpress.mit.edu/LEA/gallery.html
Leonardo is an electronic journal dedicated to providing a forum for those who are interested in the realm where art, science and technology converges.

Macworld Online
http://www.macworld.com/
Daily online version of the popular monthly Macintosh specific publication.

The Cowles/SIMBA Media Daily
http://netday.iworld.com/simba/internet.html
A daily electronic report of news about media companies, trends and personalities.

Mediascope
http://www.igc.apc.org/mediascope/about.html
"...a public policy organization...promoting constructive descriptions of health and social issues in the media..." Home page includes links to a study on TV violence, media ratings, information about the organization, and a resource index.

Media Freedom: From Gutenberg to Cyperspace
http://www.wmin.ac.uk/media/VD/MF/MFContents.html
Excerpts from Richard Barbrook's book about the contradictions of media freedom–media may be free or cheap to consume, but it isn't cheap to produce.

Media Online Yellow Pages
http://www.nlnnet.com/nlnnet/yellowp.html
Links to hundreds of media related web sites grouped in categories: TV stations, radio stations, networks, distributors, shows, products, associations, regulations, etc.

Media Professional
http://www.accessabc.com/ympc/ympmedia.html
Free monthly newsletter covering print and online media. E-mail delivery.

Tidbits
http://www.tidbits.com/
TidBITS is a free, weekly, electronic publication that covers news and views relating to the Macintosh, with a tendency to focus on Internet-related topics.

TRINCOLL JOURNAL
http://lor.trincoll.edu/tj/tj9.15.94/articles/tv.html

Utne Reader
http://www.utne.com/reader/magazine.html
Home page includes links to the current issue's table of contents, subscription to the magazine, discussion groups of hot topics, and recent articles gouped by category.

MEDIA STUDIES

Media and Communications Studies
http://www.aber.ac.uk/~dgc/medmenu.html
Resources useful in the academic study of media and communication.

Media Watchdog
http://theory.lcs.mit.edu/~mernst/media/
A collection of media criticism organizations and resources

MEMORIABILIA

Antique Radio Page
http://members.aol.com/djadamson/arp.html
Gallery of old radios. Definitely worth a try down memory lane.

Beatlefest
HTTP://www.beatlefest.com/
World's largest Beatles memoriabilia site. On line catalog brings back
lots of memories for those old enough to remember the Fab Four.

Rick's Gameroom Collectibles
http://www-odp.tamu.edu/~schulte/
A cyberride through the past when Jukeboxes and sodafountains pro-
vided teens with the best way to hear new Rock and Roll. Be sure to
check out the link for co-operated hotel radios. Wow!

Club Dead On The Web
http://artitude.com/clubdead.htm
One of the most complete Deadhead shops on the Web. Would any
Web directory be complete without at least one Deadlinks?

The Elvis Shrine
http://www.mit.edu:8001/activities/41West/Elvis.html
Got to visit the Elvis Shrine if you're a fan! Links to the

Elvis Homepage
http://sunsite.unc.edu/elvis/elvishom.html
The King and LOTS of other Elvis links.

MIDI

Brent's Midi Homepage
http://www.silcom.com/~bbain/
Complete source of information about MIDI. Links to MIDI sites,
newsgroups, news, software updates, etc. Includes a good MIDI
primer for the beginner

Minnesota Film Board

http://www.mnfilm.org/
Home page for an organization dedicated to bringing film producers
to Minnesota. Includes links to information about the state, locations
and maps, crew and production, climate and weather. Very thorough.

Minorities and Women in Television News

http://www.missouri.edu/~jourvs/gtvminw.html
A page with the results of Vernon Stone's research at the Missouri
School of Journalism. The research tracks the demographics of the
television news workforce through the 1990s.

Miramax

http://www.miramax.com/
The home page includes links to the Cafe where you can link to
information, entertainment, and products about Miramax films,
specials, contests, etc.

MOVIE AND VIDEO REVIEWS AND GUIDES

The Best Video Guide
http://rampages.onramp.net/~jbeckley/
Reviews new and upcoming videos. Includes cast and director filmographies. Features the ability to search video titles by genre.

Boxoffice
http://www.boxoff.com/
On-line version. Reviews and stories about current and upcoming movie releases. Sneak previews and interviews with actors

Cinema@The Muse
http://hyperlink.com/muse/cinema/film/cinema/mivies5.htm
International film magazine with reviews, interviews, and features on actors, directors, cult classics, etc.

What Do They Know
http://starcreations.com/abstract/fliq/fl-cri01.htm
Links to cinema criticism, stories, movie magazines, gossip, etc.

Movie Direct
http://starcreations.com/abstract/fliq/fl-cri01.htm
Links to an interesting assortment of movie related pages. Download clips from Blade Runner, look at the Woody Allen homepage, find out about Demi Moore magazines, and more.

Monitor Radio
http://town.hall.org/radio/Monitor/
The home page of the Christian Science Monitor's broadcast service includes information about Monitor Radio, and links to personalities, highlights, and program schedules.

MULTIMEDIA COMPANIES AND RELATED SITES

Multimedia Communications Research Lab
http://mango.genie.uottawa.ca/
Maintained by the University of Ottawa's Department of Electrical Engineering, this home page includes information about the lab's mission, activities, research projects, publications, and people.

Multimedia/Entertainment Industry Law
& Business Information Center
http://www.dnai.com/~pzender/
A page with links to various industry related sites including professional, legal and governmental, and entertainment sites.

MUSEUMS

HomePage of Minneapolis College of Art & Design
http://www.mcad.edu/

MOMA—New York Museum of Modern Art
http://www.moma.org/

MOMA Video Exhibit
http://www.sva.edu/moma/videospaces/homepage.htmll
Video Spaces: Eight Installations

ARTSEDGE
http://artsedge.kennedy-center.org/artsedge.html
Art Education Program hosted at The Kennedy Center

La Médiathèque du Musée d'art contemporain de Montréal
http://Media.MACM.qc.ca/

Techno-Impressionist Art
http://www.tlc-systems.com/techno/index.html
The curator of the Techno-Impressionist Gallery is:

Weegee—the Photography of Arthur Fellig
http://www.brown.edu/Facilities/David_Winton_Bell_Gallery/
weegeeGIF.html

Hi-Di
http://www.hi-d.com/

The Smithsonian Institution
http://www.si.edu/

MUSIC, MUSIC RELATED DIRECTORIES AND LINKS

Academy of Digital Music: midi files
http://busker.trumpet.com.au/adm/admusic.htm
The Academy of Digital Music specialises in MIDI files of classical
music. Download software called "Music with Meaning", and more.

Academy of Television Arts and Sciences
http://www.emmys.org/tindex.html
Areas on the site include: the 11th Annual Hall of Fame, the Emmy
Awards Photo Gallery, e-mail links to Television Academy departments
and personnel.

BMI (Broadcast Music Incorporated)
http://bmi.com
BMI is a non-profit organization representing more than 160,000
songwriters, composers, and music publishers in all areas of music.
Site includes info on repertoire, information about songwriting, perfor-
mance agreements and music business and publishing.

Cerberus Digital Jukebox
http://cdj.co.uk/
*London's Digital Jukebox is quite a piece of work. Playable audio
versions of songs are available and, if you belong to an aspiring
band, you can send music for inclusion too. Search engine allows
you to link search terms. Links to the CDJ servers worldwide.

Creative Support Services
http://www.cssmusic.com/
Provides music library services for production companies. Has Re-
alAudio links and text based information.

Cyberdog Music Industry Database
http://www.radzone.org/three_minute_dog/cyberdog.html

Digital Atomics
http://www.digital-atomics.com/
Digital Atomics Home Page links to related Web like the new Steely Dan Web Site. Sponsored by legendary recording engineer Roger Nichol. Great info on recording techniques, articles from EQ Magazine, links to musicians, etc.

eMoon Online PRoduction Resource Guide
http://www.emoon.com/

Epinicon Productions
http://www.csusm.edu/public/guests/gwie/epi.html
Epinicion Productions, Inc. is a non-profit organization to promote the Internet demo/music scene through the development of groups, giving presentations at computer expos, and aiding in the online publication of a weekly music magazine.

Headspace
http://www.headspace.com/
Music production and sound effects.

Music and Entertainment Industry Educators Assoc.
http://www.ecnet.net/users/mimusba/meiea/
Music & Industry Educators Association site. The Association aim is to provide a marketplace for ideas, strategies, and original concepts in education for the music industry.

Music/ Entertainment Industry Links
http://www.leonardo.net/jgiven/industry.html
Links to music industry Associations

NAB–National Association of Broadcasters
http://www.nab.org
Radio, job listings, science and technology, ratings, press releases, library and information, marketplace, conventions and meetings

National Broadcasting Company/General Electric Company (see television and cable networks)

New York Metro (Cyber Programming Site)
http://www.newyorkmetro.com
Original cyber programming. Will the Web replace TV? Log on and see for yourself. Soaps and cyber sitcoms await.

New York Times Company

http://www.nytimes.com/
If you register, at no fee, you can see text of the day's issue, search for previous articles, search by keyword.

NHK–Nippon Broadcasting Corporation (Japan)

http://www.ntv.co.jp/index2.html
Nippon TV network home page

National Association of Broadcast Employees and Technicians

http://www.nabet.cwa.local41.org/
An interesting set of pages that include information about the union and its activities, updates about current labor disputes, letters and publications, etc. They are also willing to forward specific information to researchers who request it.

National Association of Telecommunications Officers and Advisors

http://www.natoa.org/
A page for NATOA chapters and meeting groups to post announcements and calls for papers/projects.

National Broadcasting Company/General Electric (see also television and cable networks)

National Information Infrastructure

http://www.nii.nist.gov.html
Home page of the United States National Information Infrastructure (NII) project. Links to publications, Global Information Infrastructure (GII) reports, Council on Competitiveness, and other useful governmental agency pages.

National Press Club

http://town.hall.org/places/npc/
The NPC home page includes who the day's guest speakers and press conferences will be, links to other news and information organizations on the web, and links to Club information, coming events, speakers, etc.

National Press Photographers Association

http://sunsite.unc.edu/nppa/
The home page includes links to association information, publicaitons, educational programs, contests, member services, etc.

National Science Foundation: NSF and the Internet

http://stis.nsf.gov/od/lpa/nsfinter/wwwpages.htm
National Science Foundation page provides useful links to Internet
Society, InterNIC server, statistics of usage, and internet service
providers.

A.C. Nielsen(see also ratings)

http://www.nielsen.com/home/index.html
A series of pages with information about the company, solving busi-
ness issues, world markets, featured studies, etc.

NATIONAL OR REGIONAL NEWSPAPERS

Boston Globe

http://www.boston.com/globe/glohome.htm
on line version of the daily paper

New York Times Company

http://www.nytimes.com/
On-line version of the daily paper. Keyword searchable sections.
Sections just for on-line users.

U.S.A. Today

http://www.usatoday.com
On-line version of the newspaper

Wall Street Journal

http://www.wsj.com/
the online version of the printed paper. You must subscribe, it's free
until July 31, 1996. There will be a charge (it doesn't say how much)
after that.

WashingtonPost.com

http://www.washingtonpost.com
The Washington Post's Web site features Post and Associated Press
news feeds and a revamped Metro section called Washington World.
The service is currently free, The site replaces Digital Ink, the Post's
area on the AT&T service.

Ovation Network

http://www.ovationtv.com
alternative network, arts based programming

Omega Enterprises

http://www.webcom.com/~omegatx/

Home page includes corporate history and background, and links to news, press releases, credits & awards, and products & services.

OmniMedia's Home Page

http://www.awa.com/library/omnimedia/

Electronic publishing, bookstore area.

P

PHOTOGRAPHY

(Art)^n Laboratory/Virtual Photography
Laboratory at Northwestern University.

http://www.artn.nwu.edu/

Fantastic site documenting and actively contributing to Virtual Photography. (Art)n Laboratory is physically located at the Basic Industrial Research.

PHOTO>Electronic Imaging

http://www.peimag.com/index.htm

Home page of magazine for electronic imaging professionals. Includes links to forums, digital gallery, articles, subscription information, tutorials, items for sale, etc.

William Wegman

http://marge.infohouse.com/wegman/

The photography and video works of internationally acclaimed artist

PUBLISHERS

Links to textbook and general interest publishers

University of Missouri's College of Education–Publishers links

http://tiger.coe.missouri.edu/pub.html

Extensive links to publishers of general interest book, text books and the Textbook Information Network.

Addison Wesley Longman

http://www.aw.com/

Check out A-W's Media Lab.

Allen & Bacon

http://www.abacon.com/

Well designed site featuring extensive information on textbook offerings.

Houghton Mifflin
http://www.hmco.com/
Links to book titles, company information and employment
opportunites.

International Thomson Publishing
http://www.thomson.com/
Publishing firm's home page includes links to company information,
news and press releases, products, customer service, technical sup-
port, employment opportunities, books, journals, multimedia, etc.

Times–Mirror Higher Education Group
http://www.tmhe.com/central.html
Home page links to multimedia, permissions and copyright informa-
tion, and other Times-Mirror enterprises like the L.A. Times, Balti-
more Sun, Popular Science, etc.

Wadsworth Publishing Company/ITP
http://www.thomson.com/wadsworth/wadsworth.html
Publisher of *The Internet and Electronic Media* provides information
about book titles, links to search engines, allows you to request ex-
amination copies. *Try the interactive games linked to the
Wadsworth page.

Public Broadcasting (PBS and NPR)
http://www.pbs.org/
Links to programming, shows, specials, affiliates, news and informa-
tion about PBS, learning services, world and national news, and the
PBS store.

http://www.pbs.org/stations/
allows you to find your local affiliates and link to them if they have
home pages

http://www.npr.org/members/stations/
allows you to find your local affiliates and link to them if they have
home pages

http://www1.pbs.org/newshour/
The OnLine Newshour provides a magazine format of news and infor-
mation> RealAudio links are being added for some news segments.
> *http://www.npr.org/*
> links to real audio newscasts, special features, program
> information, national and international affiliates, tapes and
> transcripts

Penn State Public Broadcasting
http://www.cde.psu.edu/EdComm/default.html
Home page for WPSU and WPSX, includes links to information
about the stations and their programming and to links for NPR, CPB,
PBS, APTS, weather, and news.

Project McLuhan

http://www.vyne.com/McLuhan/index.html
Dedicated to update and revitalize the work of the late Marshall
McLuhan; "to develop insights and projections involving the inter-
face between culture and technology for the 1990's—and beyond."

QVC

http://www.qvc.com/
Home page includes links to the QVC shop, corporate headquarters,
news and press releases, backstage, and FAQs and contacts.

R

RADIO RELATED SITES

Audio Concepts and Engineering
http://www.infi.net/~jlridge/
engineering and consulting services for radio stations

http://www.radiotv.com
provides links to television and radio stations that show live signals
over the internet

http://www.rcsworks.com
software products for radio

http://www.ccc-dcs.com
products for the digitally integrated radio station

http://www.iea.com/~keithh/wre.html
White Rabbit Enterprises provides radio engineering and compli-
ance services

http://www.highbbs.com/scott.htm
computer automated systems for radio stations

RealAudio SITES

AudioNet
http://www.audionet.com

Audiosoft
http://www.audiosoft.com//home_gb.htm
Provides Real Time Audio software and services on the Web.

RealAudio

http://www.realaudio.com/

Home page of RealAudio. Download software to run RealAudio players and links to many sites that have audio programming. Information is available in serveral langauges. Here are a few:

> *http://www.npr.org/*
> *http://www.realaudio.com/contenp/abc.html*

RADIO AUDIO HISTORY, AND RELATED LINKS

HELL'S BELLS: A Radio History of the Telephone
http://www.cac.washington.edu:1180/nic-news/clippings/1993/08.september/0258.html

Mid-America Radio History
http://www.littleblue.com/kcradio/history.html (5k)

RADIO HISTORY IN NORTH CAROLINA
http://sunsite.unc.edu/journalism/radio.html

A history of 3GL
http://www.ne.com.au/~gasp/gl/gl_index.htm

AIRWAVES ONLINE
http://radio.aiss.uiuc.edu/~rrb/AIRWAVES_ONLINE/0626.html

The History of Radio
http://www.pacificrim.net/~radio/old_html/hist/history.html

An overview of the history of radio, select by your area of interest.

BACKGROUNDER: WHAT IS AMATEUR RADIO?
http://www2.gvsu.edu/~kc8ayz/whatis.htm

Radio News Salaries
http://www.missouri.edu/%7Ejourvs/rasalary.html

A page showing the results of a series of surveys tracking the salary of broadcast journalists compared to the consumer price index. This page focuses on radio professionals.

Stations And Station Lists
http://www.cmmnet.com/stations.htm

> #### Gothenburg Radio & TV Stations
> *http://www.etek.chalmers.se/~acne/radio.html*
> This list is sorted by frequencies

Radio Stations On The Net Radio
http://www.catt.ncsu.edu/~drmellow/country/radio.html

Radio/TV Dial Pages
http://metronet.lib.mi.us/MIKEL/radio/index.html

Links to AM and FM radio and television stations. Long, but not exhaustive lists in each category.

RADIO STATIONS AND NETWORKS BROADCASTING ON THE INTERNET

WXYC–University of North Carolina at Chapel Hill
http://sunsite.unc.edu/wxyc/simulcast/index.html

KJHK - Univerity of Kansas School of Journalism
http://www.cc.ukans.edu/~kjhknet/index.html

RADIO KOREA
http://www.radiokorea.com/ram/live.ram

RADIO STATIONS WITH HOME PAGES

KCBS Arrow–93FM
http://www.arrowfm.com/
Los Angeles classic rock station. Page includes links to information about the station, dining and entertainment in Los Angeles, concert and artist information, and a page of games and trivia.

KRHF 102.7–Radio Free Hawaii
http://www.lava.net/radio-free/
Links to station information and ideas and opinions about comercial radio from the general manager.

KEDG 93.7–Minneapolis/St. Paul
http://www.937edge.com/
Alternative station home page with links to station information, music information, news, chat, and live netcasts with the proper software.

KFAB 1110 AM–Omaha
http://www.kfab.com/select.html
Links to station information, local news and sports, and pages of national news and sports organizations.

KING FM 98.1–Seattle
http://www.king.org/kingfm/welcome.htm
Inlcudes typical links to station information, etc., as well as a searchable databese of playlists for the past six months.

WABC–770AM
http://members.gnn.com/thebighump/wabc11.htm
(Unofficial page) Links to station information, news, weather, Djs and personalities.

WAYS 99.1–Macon, GA
http://www.accucomm.net/com/ways/
Oldies station with links to station information, personalities, contest and events, news, class reunions, and oldies music information.

WEQX 102.7–Manchester, VT
http://www.weqx.com/intro.html
New rock station with links to station information, personality bios, feature programming, awards, contests, concerts, event, and advertising information.

WLUM 102.1–Milwalkee, WI
http://www.newrock.com/
A new rock station's home page with lots of links to station information and events, concerts, city events, contests and give-aways, and an on-line request service. An interesting page, more than just the same old stuff.

WTWR–98FM
http://www.foxberry.com/Tower98/
Home page for radio station in Monroe, Michigan with links to playlists and requests, staff bios, contest results, newsletters, events, promotions, etc.

RECORD COMPANIES

FREQUENCY–Record Companies
http://www.ithaca.edu/rhp/ictv/ictv6/recco.html

Music Record Companies Record Companies on the Web
http://olympia.ucr.edu/sshah/music/records.html

Record companies index
http://www.stack.urc.tue.nl/%7Ejeroen/label/

Record Companies (Records CDs and Tapes)
http://galaxy.einet.net/galaxy/Business-and-Commerce/
Consumer-Products-and-Services/Arts-and-Crafts/Music/
Records-CDs-and-Tapes/Record-Companies.html

SUBCULTURE–Record Companies
http://www2.best.com/~ modern/sub/rec_co.html

UKdirectory–Record Companies
http://www.ukdirectory.com/ent/rec.htm

REFERENCE WORKS AND LINKS

Book Stacks Library
http://www.books.com/lib1.htm

Catalog of Electronic Text on the Internet
http://www.lib.ncsu.edu/stacks/alex-index.html

Desktop Reference
http://www.ll.mit.edu/ComLinks/deskref.html
Incredible assortment of reference materials available. This is like a one stop shopping center for information.

Electronic classrooms
http://mice.uio.no/mice/munin.html

Kula Ring–How to Cite Electronic Media
http://www.ucalgary.ca/~ kularing/quote.html

The On-Line Reference Desk
http://www.sil.org/general/reference.html
Has excellent links to many different types of research material.

Planet Earth's Home Page of Books and Libraries
http://www.nosc.mil/planet_earth/info.html
Links to a global showcase of information references

The World-Wide Web Virtual Library
http://hirsch.cosy.sbg.ac.at/www-virtual-library_culture.html
Listings on culture

Ratings

http://web3.starwave.com:80/showbiz/numbers/tv/tv.html
A page maintained by Mr. Showbiz containing the previous week's
Nielsen tv ratings. Also includes links to other Mr. Showbiz pages
including enteratinment news, reviews, awards, personalities, etc.

A.C. Nielsen
http://www.nielsen.com/home/index.html

S

San Francisco Digital Media Center

http://www.well.com/user/sfdmc/sfdmc.html
The home page of a center for storytelling.. Links to information
about the center, special events, digital storytelling, etc.

Sci-Fi Channel (see television and cable networks)

http://www.scifi.com/

SCREENsite: Film and TV Studies

http://www.sa.ua.edu/TCF/contents.htm
A reference page for film/TV/video educators. Links to education,
research, references, production, etc.

Scripts Howard Media

http://scripps.com/
Scripps Howard Media, with interests in newspapers, television and
cable operators & networks. Home page includes links to company
news and events, and each of the individual media interests.

Home of SHOCKWAVE

http://www.macromedia.com

Smart Clothes: Wearable Computing Intro Page

http://wearables.www.media.mit.edu/projects/wearables/

Steve Mann, Personal WWW page: "WearCam"

http://18.85.0.199/myviews4.html
Steve Mann, Personal WWW page: "WEARCAM", myviews.html
http://18.85.0.199/myviews.html

SOAP OPERAS AND RELATED LINKS

AIRWAVES SOAP-OPERA Pages
http://radio.aiss.uiuc.edu/%7Errb/soap.html

Chris Barker Soaps, Sex and Ethnicity
http://socserv2.mcmaster.ca/soc/qualitatives/barker.htm
Gender interpretations of soap apera amongst Asian teen in the UK
provided by Chris Barker, Senior Lecturer in Media Studies, University of Wolverhampton...

Community J's Soap Opera Page
http://www.geocities.com/Hollywood/2006/soaps.html
Get all the latest details on your favorite Soap Operas!

Love and Ideology in the Afternoon
http://www.indiana.edu/~iupress/fall-catalog/mumford.html
How do soap operas reinforce dominant ideas? Tune in to find out

More soap links
http://tvnet.com/UTVL/soa_list.html

Net-therapy
http://www.rochesterdandc.com/div/wys/dw6033b.html

The Popularity of Soaps: Merris Griffiths
http://www.aber.ac.uk/~ednwww/merris1.html
Why are soap operas so popular? First hand info about UK soaps.

Psychic Encounters' Soap Opera Page
http://soho.ios.com/~psychic/soap.html (

Soap Links Soap Home Pages
http://www.port-charles.com/soaps/
Soap opera pages maintained by fans.

The Ultimate TV List: Soap Opera List
http://tvnet.kspace.com/UTVL/soa_list.html
Click on names of shows to view the related pages. Links to soap
mailing lists.

Sony Corporation (Columbia Pictures)

http://www.sony.com
Sony homepage providing links to many related corporate enterprises including theaters, radio, gear, tv, music, games, electronics, movies. From this site you can access related media pages:

http://www.spe.sony.com/Pictures/tv/wheel/exclusive.html
Home page for SONY Pictures Entertainment
http://www.spe.sony.com/Pictures/index.html
http://www.swnetworks.com/Sony Worldwide
alternative, classical, talk, jazz, country, hiphop, links to
artists, buying CDs

Society of Motion Picture and Television Engineers

http://www.smpte.org/
SMPTE home page provides links to ifo about the organization,
conferences, publications, membership, jobs, standards, news and
notes, committees, etc.

Sound Wave

http://soundwave.com/
A web page for audio professionals. Includes information about be-
coming a member of Soundwave, a directory of other members, trad-
ing, jobs, news, etc. Also dozens of links to audio related web sites.

SPEECH COMPRESION

GSM 06.10 lossy speech compression page at
http://www.cs.tu-berlin.de/~jutta/toast.html

Storytelling on the Web

Jenny Holzer
http://adaweb.com/adaweb/context/artists/holzer/holzer1.html
Internationally acclaimed artist using the Web in her work.

STYLE MANUALS AND STYLE GUIDELINES FOR RESEARCH PAPERS

A Style Sheet for Internet Sources:MLA Style
*http://www.lib.berkeley.edu/TeachingLib/Guides/Internet/
MLAStyleSheet.html*

Citing Sources for Academic Papers
http://www.indiana.edu/~wts/wts/citing.html

Using APA
http://fur.rscc.cc.tn.us/OWL/UsingSources/APA.html

Scitex Corporation

http://www.scitex.com/stcl/prods/stc_mul.html
video and multimedia

T

Techtronics
http://www.tek.com
A technology company dealing in color printing, video systems and network displays

TELECONFERENCE HARDWARE

Howard Enterprises
http://www.howent.com
Teleconference cameras

Internet Voice Communication Software
http://rpcp.mit.edu
DSP Group's TrueSpeech
http://www.dspg.com/plugin.htm

TELEPHONY

Andrew Sears' Internet Telephony Page
http://rpcp.mit.edu/~asears/main.html

Internet Phone Software (See also CU-SeeMe)

Vocaltec
http://www.vocaltec.com

PGPfone
http://web.mit.edu.network/pgpfone

Michael Mathog and Eric Knorr webphone review—C|NET
http://www.cnet.com/Content/Reviews/Compare/Wphone

The Voice on Net
http://www.von.com/
Excellent Telephony references.

TELEVISION, CABLE HISTORY AND RELATED LINKS

Ad Age—Facts & Features—History of TV Advertising
http://www.adage.com/Features/TV/

History of Cable TV
http://www.island.net/~shaw/history.htm

Internet & Television Technology Timeline
http://www.intercast.org/timeline.html

TELEVISION AND CABLE NETWORKS, USA

A & E (Arts and Entertainment)
http://www.aetv.com
Guides to programs, listings, links to the History Channel, and the A&E store.

All News Channel
http://www.allnews.com/

America One Television
http://www.americaone.com/index2htm
Satellite based television network

America's Talking
http://www.ameritalk.com/
Subsidiary of NBC television. Dedicated to talk programming.

American Broadcasting Company
http://www.abctelevision.com
News, programming, monthly events, some shows highlighted on home page

American Independent Network
http://www.aini,com/
Satellite based family oriented television.

American Movie Classics
http://www.amctv.com/
Imaginative web page includes scheduling information. *We particularly like AMC's annual film preservation festival and search for lost films.

Black Entertainment Television
http://www.betnetworks.com/
Sophisticated homepage features info on bET nets, magazines, shows and specials. 3-D graphics are well worth a look.

BET Jazz
http://www.betnetworks.com/jazz/index.html
Features highlights about spotlighted artists as well as program listings.

Book TV
http://booktv.com/
Satellite based program homepage offers home shopping capabilities for book lovers.

BRAVO
http://www.bravotv.com/
An interesting home page with many program based links, interviews with stars, hyperlinks to texts and viewers/readers comments.

C-SPAN
http://www.c-span.org/
Includes real audio links to House and Senate activities, links to many government FTP servers, information, public affairs hotlinks. Check out C-SPAN FTP and Gopher servers.

Cable Radio Network
http://www.calypso.com/radio/
Program, format, demographic information related to this radio programming service.

Cartoon Network
http://www.filmzone.com/SpaceGhost/cartoonet.html
Homepage with links to some cartoon characters such as Space Ghost.

Channel 1 News Network
http://www.hacienda.com/
Homepage of the school based network. Links include pop quizzes, polls, on-going program notes and more.

Christian Broadcasting Network
http://www.cbn.org/
Link to the 700 Club and the CBN network; links to ministries and other CBN activities.

CNBC
http://www.cnbc.com/
Stock market information as well as program schedules. Glossary of stock market terminology is useful.

Comedy Central
http://www.comcentral.com/
CyberSatire! Finally a place that's hardly ever serious. *One of our favorite bits is Indecision '96.

CABLE NEWS NETWORK (various links)

CNN Entertainment
http://www.cnn.com/SHOWBIZ/index.html

CNN Food and Health News
http://www.cnn.com/HEALTH/index.html

CNN Interactive (news on the Web)
http://www.cnn.com/

CNN Sports
http://www.cnn.com/SPORTS/index.html

CNN U.S. News
http://www.cnn.com/US/index.html

CNN World News
http://www.cnn.com/World/index.html

CNN/Time AllPolitics
http://www.allpolitics.com/

CNN Weather
http://www.cnn.com/WEATHER/index.html
World-wide weather Forcasts, weather maps, and storm
data, plus local forcasts for 300 U.S. cities.

CNN Networks Page
http://www.cnn.com/networks.html
Schedules for the CNN Networks. Studio tours online dis-
cuss how news is collected, edited and broadcast.
Provides some historical data about the network.

Columbia Broadcasting System
http://www.cbs.com
Information and links about CBS Television including shows, affili-
ate lists, news about CBS
> *http://www.cbs.com/remotes/affiliatemap.html*
> Allows you to find local affiliates and link to them if they
> have home pages

CourtTV
http://www.cnn.courttv.com
Imaginative site with links to court tv related events. Court opinions
and expert opinions available. *We particularly like the glossay of
legal terms which may be either browsed or searched.

Discovery Channel
http://www.discovery.com/
Very sophistocated and complete home page. Many links to
programs and materials related to programs. Search tools and
helpers allow you to customize Discovery start pages. *Highly rec-
ommended.

ESPN
http://espnet.sportszone.com/
Home page inlcudes sports headlines with links to the full stories,
scores and statistics of in season sports,

The Family Channel
http://www.famfun.com/

Fox Broadcasting
http://foxworld.com/entertainment/
Links to affiliates, featured shows and events, show listings and
schedules, games and fun stuff, chat rooms and message boards
> *http://foxworld.com/entertainment/america/index.html*
> Allows you to find local affiliates and link to them if they
> have home pages
> *http://www.foxnetwork.com/*
> A short home page linking to kids, entertainment and sports
> *http://www.foxnetwork.com/kids/index.html*
> A page designed for kids to use. Links to schedules of kids
> shows, explanations of the internet, the kids club and kids
> magazine, games, contests, etc.

http://www.foxnetwork.com/sports/index.html
Links to sports news, scores and stats, Fox run BBS on an-
nounced topics. No link back to the other Fox pages.

Home Box Office
http://www.hbo.com/
Info about HBO schedules and programming, links to selected HBO
shows and events.

MTV
http://www.mtv.com/
Home page of the MTV Networks, includes links to music, music
news, credits, annimation, tubescan, headshop, standards, jobs, etc.

National Broadcasting Company
http://www.nbc.com
News stories, interviews, programming and show information, links
to affiliates.

> *http://www.msnbc.com*
> Interactive material based on current NBC news stories.
> *http://www.nbc.com/news/index.html*
> Links to texts of current news stories
> *http://www.nbc.com/stations/index.html*
> Allows you to find local affiliates and link to them if they
> have home pages.

Public Broadcasting Service
http://www.pbs.org/
Links to programming, shows, specials, affiliates, news and informa-
tion about PBS, learning services, world and national news, and the
PBS store.

QVC
http://www.qvc.com/
Home page includes links to the QVC shop, corporate headquarters,
news and press releases, backstage, and FAQs and contacts.

Sci-Fi Channel
http://www.scifi.com/
The Dominion is the Sci-Fi Channel's web site. It includes contests
and events, information about specials and feature series, articles
and reviews, audio, video, and images for downloading, and links to
other sci-fi related web sites.

The Travel Channel
http://www.travelchannel.com/
Links to program highlights, vacation getaways, travel facts and
opinions.

Turner Classic Movies
http://www.turner.com/tcm/tcmhome.html
The home page offers links to TCM events, awards, news and press
releases, schedules, coming attractions, links, etc.

The Weather Channel
http://www.weather.com
Excellent interactive page allows user to explore many weather
related functions, inlcuding boating information.

UPN—Paramount Television Network/Viacom
http://www.upn.com/
Official UPN page, not quite up and running as of 5-16-96. Looks like
they might be having live video for it, hard to tell.

http://www.cdsnet.net/vidiot/UPN/upn.html
The unofficial UPN page, includes programming schedule, sum-
mary of articles from *Broadcasting & Cable*, and links to press re-
leases, network execs' pages, some shows, some affiliates

TELECOMMUNICATIONS ACTS RELATED SITES

Benton Foundation's Communications Policy Project
http://www.cdinet.com/Benton/

Telecommunications Act Summary
http://www.technologylaw.com/techlaw/act_summary.html
Blumenfled & Cohen, a law firm specializing in technology-based
law, provides a series of useful pages describing the implications of
the Telecommunications Act of 1996. Digests are highly readable.
Links to other law related sites.

Telecom Information Resources
http://www.spp.umich.edu/telecom/telecom-info.html
A searchable list of web references to technical, economic, public
policy, and social aspects of telecommmunications, including voice,
data, wired, wireless, cable, satellite, etc.

TELEVISION PROGRAMS AND RELATED LINKS

Attractions Magazine—Home Page
http://www.infomagic.com/~hlr/celebs/magazine/tv/tvtheme/
Search for related links by type.

Cool TV Listings
http://www.student.net/tv/index.html
*A fabulous site. Cool TV listings; household appliance; Look up tv
shows; get e-mail reminders to watch shows; Student Net TV List-
ings; Student Net Tv Reminder; Student TV Search; and more.

Fall 96 Prime Time Network Television Schedule
http://www.amerisites.com/96prime.html

IAN AND ABS' HOME PAGE
http://www.computan.on.ca/~grahame/oltl/links.html
Search for televion and movie sites, look up themes to television
shows. Look up any actor or any movie through this page.

Media Online Yellow Pages: TV Shows

http://www.nlnnet.com/nlnnet/yel_show.html

Info about Hollywood produced programs.

NBC Fall Prime Time

http://kvbc.com/kvbc/nbc_fall.html

Nerd World : TELEVISION SHOWS

http://www.tiac.net/users/dstein/nw1228.html

TV Links

http://www.leba.net/~jrodkey/tv01.html

TV Net — Forum

http://tvnet.com/forums/tvshows.html

TV Net—Ultimate TV List

http://tvnet.com/UTVL/

They claim to have 5142 Links for 796 Shows, including 1209 WWW pages. We don't know how accurate this is. We haven't tried them all.

The TV Shows Page

http://www.primenet.com/

TV Talk

http://www.thegriffs.com/tv-talk/

This is a place where fans of TV shows can discuss the shows in a bulletin board type fashion.

Yahoo!—Entertainment:Television:Shows:Dramas

http://www.yahoo.com/Entertainment/Television/Shows/Dramas/

Time Warner Communications

Time-Warner-Pathfinder

http://pathfinder.com/@@SiF7HwUAJ9yj7Efg/pathfinder/Home_low.html

Time Warner's "Pathfinder" page groups by category links to all the Time Warner holdings and other fun pages in those categories. Categories include news, money & business, sports, entertainment, music, tv & film, weather, travel, learning, hobbies, health, etc.

TSTV KVR 9 Web

http://www.utexas.edu/depts/output/www/tstvframe4.html

The home page of the student TV station at the University of Texas with links to information about the station, staff and programming. Also includes links to 24 hour netcasting.

Welcome to TV Net!

http://www.tvnet.com/tvnet/TVnet.html

Hundreds of links to TV related pages including: national, international, broadcast, cable, and features of industry press releases, resources, job, classifieds, reviews, "webcasting," chat forums, etc.

TV News Salaries

http://www.missouri.edu/%7Ejourvs/tvsalary.html
A page showing the results of a series of surveys tracking the salary of broadcast journalists compared to the consumer price index. This page focuses on television professionals.

T.V. Resource Guide

http://www.teleport.com/~celinec/tv_usent.htm
A list of usenet newsgroups for television shows. Mostly rec.arts.tv and alt.tv.(show name)

TELEVISION PRODUCTION

Production Weekly

http://members.aol.com/prodweek/index.html
Weekly breakdown of projects in pre-production, preparation and development for film, television, music videos, commercials, etc., covers of the major markets from Los Angeles to New York and Canada.

TELEVISION STATIONS

KGO Channel 7—San Francisco, CA

http://206.15.70.61/
An ABC owned & operated station. Home page includes links to entertainment information, news links including real audio of local and national news, headlines, weather, press releases, and educational links including a newsroom tour.

KOAA—Colorado Springs

http://www.koaa.com/
NBC affiliate home page with station information and links to news weather, sports, programming, staff bios, NBC pages, editorials, jobs, and live camera shots uptdated every 10 minutes.

KPAX—Missoula, MT

http://www.kpax.com/
CBS affiliate with links to news % sports, weather, special events, production, marketing, program schedules, etc.

KTFO TV41—Tulsa, OK

http://www.galstar.com/~upn41/index.html
UPN affiliate home page includes links to station information, and popular UPN shows like Babylon 5, Star Trek, and Highlander.

KYES TV5—Anchorage, AK

http://www.alaska.net/~fireweed/kyes_basic.html
Affiliated to both UPN and WB. Home page includes station information, including how to get the best reception, information about and links to Babylon 5, as well as links to various UPN and WB pages.

WHDH TV—Boston MA

http://www.whdh.com/

Home page with station information, plus links to news stories, weather, sports, programming, jobs, lottery, NBC, etc.

WMBD TV31—Preoria, IL

http://www.wmbd.com/

Includes links to news, weather, sports, station information, CBS, jobs, advertising, kids page, crime tips, programming, etc. Plus you can have the weather forcast emailed to you every morning.

WOLO—Columbia, SC

http://www.wolo.com/index.html

Page of station information, plus links to poular syndicated programs, ABC programming pages, local weather, community links, and broadcasting links (Ie. NAB, BBC, CBC, FCC).

WTLH TV—Tallahassee, FL

http://www.fox49.com/

Fox affiliate home page with links to the station's programming schedule, and popular Fox shows.

WTVC—Chattanooga, TN

http://www.NewsChannel9.com/

ABC affiliate home page with schedule of local news, and links to news stories, weather, health stories, business stories, and entertainment information and scheduling.

Twentieth Century Fox

http://www.tcfhe.com/

Links to the history of Twentieth Century Fox, by decade, movies grouped by family features, studio classics, selections, premier seriese, or featured movies.

Viacom Corporation

http://www.viacom.com/viacom/index.html

Corporate home page has linked to the businesses (film, tv and radio networks, cable, publishing, interactive, recreation), the idea (company history and mission), facts and figures (financial information) and announcements (current and archived company news).

VIDEO AND RELATED SITES
Internet Video Communication Software
PictureTel
http://www.pictel.com

CU-SeeME
http://cu-seeme.cornell.edu
http://www.cu-seeme.com

InterVu
http://www.intervu.com

VivoActive
http://www.vivo.com

XingMPEG
http://streams.xingtech.com

Michael Sattler
http://www.indstate.edu/msattler/sci-tech/comp/CU-SeeMe/index.html
Good source for technical information on CU-SeeMe

Video on Net
Conncetix Quickcam
http://www.connectix.com
Teleconference cameras

VideoLabs' Flexcam
http://www.flexcam.com
Teleconference cameras

Web-Voyeur
http://www.rainier.net/%7Elarry/web-voyeur/
The web voyeur is a list of (mostly) live video views available on the Web, current video "snapshots" from around the world.

Bill Woodland's Undernet IRC
http://www.realtime.net/~wcw
CU-SeeMe Info Page

UPN–Paramont Television Network/ Viacom (see also television and cable networks)
http://www.upn.com/
The official upn page, not quite up and running as of 5-16-96. Looks like they might be having live video for it, hard to tell.

United Media

http://www.unitedmedia.com/
Syndicator of feature and editorial comics.

Universal Studios

http://www.mca.com/tv/
The home page of MCA/Universal Television, contains links to all
the mca shows

http://www.usf.com/index.html
Universal Studios
Information about the studio/theme park, with links to attractions,
guest services, tickets and reservations, and what's new

U.S. West Corporation

http://www.uswest.com/
Corporate (telecommunications, wired and wireless networks, interac-
tive multimedia) home page with links to company news & info, prod-
ucts & services, employment, and an index of all the US West pages.

Warner Brothers

http://www.warnerbros.com/
the Warner brother's home page, includes links to highlighted pro-
jects in all areas and links to the areas themselves (i.e., tv, movies,
kids, dc, home video, music)

http://www.cs.brandeis.edu/~aaron/wb/wb.html
The unofficial WB network page. offers information about program-
ming, affiliates, wb news, and lots of links to wb related sites (i.e.,
kids' stuff, animaniac

Westinghouse Broadcasting—CBS

http://wcsd.westinghouse.com/pdf/pdf_mp.htm
Homepage for Acrobat supported company information.

Wheel of Fortune Pages

http://www.wheelfortune.com/
Links to the popular syndicated game show with information related
to the program and upcoming events. Other links allow you to play
The Wheel on line (not good for a slow modem).

Weather Channel

http://www.weather.com/weather/
Home page includes links to Weather Channel information (Ie. history, schedules, personality bios, etc.), current weather, trivia contests, weather maps, and more.

Women in Film and Television

http://www.deakin.edu.au/arts/VPMA/wift.html
An organization directed at promoting women in the industry. The home page includes information about the project and links to publications, discussion forums, and information about current and new telecommunications technologies.

Women's Wire

http://www.women.com/

World Press Freedom Committee

http://pathfinder.com/@@SiF7HwUAJ9yj7Efg/pathfinder/
Home_low.html
Home page inlcudes background, mission, membership, programs, publications, and contacts.

Glossary

Anonymous FTP A file retrieval program with a common public password. *See also* File Transfer Protocol.

Archie A search program providing listings of the locations of files available by anonymous FTP. Also the automated indexing program upon which such searches are based.

Archive (verb) To combine two or more files into one.

Archive site A computer that stores and provides access to a specific collection of files.

ASCII file A file encoding format, developed by the American Standard Code for Information Interchange, that represents upper- and lowercase letters, numbers, punctuation marks, and basic operations (for example, tab, enter) by numbers from 1 to 128. A file encoded in standard keyboard characters—as opposed to a binary file. An unformatted text file. *See also* Binary file.

Binary Represented by ones and zeros, for example, 11001001.

Binary file A file encoded in binary code. More often, a file encoded with characters including but not limited to those found on a standard keyboard. Executable programs are stored as binary or nontext files.

Bit (binary digit) A single unit of data.

Browser Specifically, a program for reading the Hypertext Markup Language of World Wide Web pages. More generally, any program for following a path of menu items or other links.

Bulletin board system (BBS)
An on-line computer network offering information and messages. Generally nonprofit and local or interest-group focused. *See also* On-line service.

Byte Eight bits. The number of bits necessary to indicate a single number or letter of the alphabet.

Chat A program or forum for on-line group discussion.

Client A computer system, program, or user that requests services from another computer, the server, on a network. *See also* Server.

Compression The reduction in the size of a file to achieve a smaller storage space or faster transmission.

Cyberspace The electronic world of computers and their users. The conglomerate information and resources of the Internet and other networked communication services.

Database Any collection of data or interrelated files that can be accessed in a variety of ways.

Decode To convert an encoded file back to its original form. *See also* Encode.

Digital Generally, using numbers or other discrete units– as with a digital, as opposed to analog, watch. The term is synonymous with any binary– coded system or device, hence essentially synonymous with *computer*.

Directory An index of the location of files, as on a hard drive of a computer. Directories create the illusion of file drawers, even though the files may be physically dispersed.

Discussion Group A forum in which subscribers communicate by exchanging group E-mail messages.

Domain A portion of the hierarchical system used for identifying Internet addresses. Key domains include: .COM (commercial), .EDU (educational), .NET (network operations), .GOV (government), and .MIL (military).

Domain Name System (DNS)
The system for translating alphabetic computer addresses into numerical addresses.

Download To receive information or files from a remote computer.

E-mail Electronic mail.

Electronic texts Texts encoded for electronic storage or transmission.

Emoticon A symbol used to indicate emotion or the equivalent of a voice inflection in an E-mail message. *See also* Smiley.

Encode To convert a file from one format to another, as from binary to ASCII for E-mail transmission.

Encryption The coding of data for purposes of secrecy and/or security.

Extension An abbreviation (usually three-digit) added to file names to indicate the file format.

FAQ *See* Frequently asked question.

File Stored computer data representing text, numeric, sound, or graphic images.

File transfer protocol (FTP) A program for transferring files from one computer (a host) to another (a client), especially for retrieving files from public archives. *See also* Anonymous FTP.

Frequently asked question (FAQ) A common name for files compiling answers to common questions, hence providing introductory information on a topic. Often appearing in newsgroups.

FTP *See* File transfer protocol.

Gateway A device, program, or site providing access to a network, generally between otherwise incompatible formats or protocols.

Gopher A hierarchical menu program for accessing information across the Internet.

Gopherspace That part of the Internet accessible by Gopher, that is, on Gopher servers and listed in Gopher menus.

Graphic interface A computer interface that displays graphic elements and icons rather than only lines of simple text. A computer interface negotiated with a mouse as well as with cursor keys.

Home page An initial menu page of a World Wide Web site, written in Hypertext Markup Language (HTML).

Host A computer that allows other computers to communicate with it.

Hypertext Markup Language (HTML) The system of embedding retrieval commands and associated addresses within a text; used for documents on the World Wide Web.

Hypertext Transfer Protocol (HTTP) The program controlling the transmission of documents and other files over the World Wide Web.

Hytelnet A menu-driven version of telnet. A menu of telnet sites.

Icon A graphical representation or symbol representing a file, program, or command on graphic-interface programs.

Interface The connection between two devices. More particularly, the nature of the display screen used for communication between user and computer.

Internet The worldwide "network of networks" connected to each other using the Internet protocol and other similar protocols. The Internet provides file transfer, remote login, electronic mail, and other services.

Internet Protocol (IP) A protocol involving packets of data traversing multiple networks. The protocol on which the Internet is based.

Internet Service Provider A national or local company providing access to the Internet.

Internet Society (ISOC)
A nonprofit, professional membership organization that sets Internet policy and promotes its use through forums and the collaboration of members.

IP *See* Internet Protocol.

IP address The 32-bit address, defined by the Internet Protocol and represented in dotted decimal notation, cf. 171.292.292.23, assigned to a computer on a TCP/IP network.

Jughead (Jonzy's Universal Gopher Hierarchy Excavation and Display) A variant of Veronica that searches directories on a select number of Gophers.

Key-word search program
A program for searching a database or set of files for a specific term or terms.

Listserv One of a number of listserver programs.

Listserver An automated mailing list distribution program providing the basis of many mailing list subscription or discussion groups.

Logoff To relinquish access to a computer network.

Logon To gain access to a remote computer or computer network.

Mailing list A system of forwarding messages to groups of people via E-mail.

Microsoft Windows A graphic-interface operating system from Microsoft Corporation for IBM-compatible computers.

Modem (Modulate/Demodulate) A device that enables computers to transmit and receive information over telephone lines by converting between digital and analog signals.

Mosaic The initial World Wide Web browser program.

Multimedia Integrating text, sound, and graphics.

Netiquette Proper social behavior on a network.

Netscape A leading World Wide Web browser program.

Network A communication system consisting of two or more computers or other devices.

Network Information Centers (NICs) Organizations providing documentation, guidance, advice, and assistance for a specific network.

Ntalk New talk, a new form of talk program. *See also* Talk.

On Ramp *See* Gateway.

On-line service A centralized computer network offering subscribers a variety of services including E-mail, file transfers, chat groups, and business, entertainment, and educational materials. Any service accessed by telephone.

Operating system The primary program of a computer, cf. MS-DOS, Windows, Macintosh System 7. The operating system determines the basic commands and the appearance of the screen.

Prompt A message or signal in a computer program requesting action by the user.

Protocol A formal description of operating rules.

Search program Any program providing direct examination of a database.

Server A host computer serving a special function or offering resources for client computers, whether as a storage device in a local area network or as a Gopher site on the Internet.

Shareware Commercial software available initially free on a trial basis.

Smiley An icon used to convey emotion or innuendo in texts, e.g., :-) (glad), :-[(disappointment).

Spamming Deluging someone with unwanted messages as punishment for inappropriate use of an on-line service or the Internet.

Surfing Random or otherwise seemingly undirected browsing, as of the World Wide Web.

Talk A program in which two users exchange on-screen messages.

Telnet An Internet program for accessing remote computers.

Text interface A screen display limited to lines of keyboard characters.

Uniform resource locator (URL) A format for indicating the protocol and address for accessing information on the Internet; a name identifying documents and services on the Internet.

Unix A popular operating system important in the development of the Internet.

Upload To send files to a remote computer.

URL See Uniform resource locator.

Usenet A network and program for reading and posting messages on public newsgroups; accessible in whole or in part via the Internet or many on-line services.

Veronica(Very Easy Rodent-Oriented Net-Wide Index of Computerized Archives) A program developed at the University of Nevada at Reno in late 1992 for searching Gopher menus.

Wide Area Information Server (WAIS) A program for searching collections of documents for specific terms.

Word processor A computer program that replaces all the operations formerly associated with a typewriter.

World Wide Web (WWW) A hypertext-based system for finding and accessing Internet resources.